HOW TO DRAW MANGA
Making Anime

Co-authored by
Yoyogi Animation Gakuin & AIC

Drawing: Hiroyuki Kitazume
 Matsuri Okuda
 Akihiro Izumi

HOW TO DRAW MANGA:
Making Anime
Co-authored by Yoyogi Animation Gakuin and AIC

This book was first designed and published in 1996 by Graphic-sha Publishing Co., Ltd.
This English edition was published in 2003 by
Graphic-sha Publishing Co., Ltd.
1-14-17 Kudan-kita, Chiyoda-ku, Tokyo 102-0073 Japan

Main text: Yoyogi Animation Gakuin
Drawing: AIC (Hiroyuki Kitazume, Matsuri Okuda, Akihiro Izumi)
Original cover art: Hiroyuki Kitazume
Photography: Katsuyuki Kihara
Assistance: Pioneer L.D.C. Co., Ltd. / Studio BIHOU
English main title logo design: Hideyuki Amemura
English edition layout: Reminasu
English translation management: Língua fránca, Inc. (an3y-skmt@asahi-net.or.jp)
Planning editor: Motofumi Nakanishi (Graphic-sha Publishing Co., Ltd.)
Foreign language edn. project coordinator: Kumiko Sakamoto (Graphic-sha Publishing Co., Ltd.)

First printing: January 2003
Second printing: January 2004
Third printing: August 2004

ISBN: 4-7661-1239-3
Printed and bound in China

Table of Contents

Excerpted from "Shiawase Kun" by Hideyoshi Okada

Overview of AIC

Anime International Company Inc. (AIC) was established in 1982 for the purpose of releasing animated films globally. The company focused its attention on releasing animations on video even before the popularization of the medium. AIC released two original video animations in 1985, "Megazone 23" and "Iczer 1," breating new life into the animation world. Since then, it has created over 200 titles, including "Gal Force," "Bubble Gum Crisis," "Zeoraima," "Fight! Iczer 3," "Peacock King," "Vampire Princess Miyu," "Dangaio," "Bastard!!," "Moldiver," "The Hakkenden, Macross 2," "Ah! My Goddess," "El Hazard," "Tenchi Muyo!" and "Armitage III." Every one of these titles has been serialized. "Tenchi Muyo!," "El Hazard," and "Ah! My Goddess" have made their way to television and the big screen. AIC plans to continue to make lively and exciting animated films.

AIC has also established other divisions focusing on CG business (AIC Sprits) and publishing business (AIC Club). They plan, develop and produce anime-related computer games, CD-ROMs, console games, publications and other merchandises.

The authors of this book, Hiroyuki Kitazume, Matsuri Okuda, and Akihiro Izumi are engaged in animation production work at AIC. Besides the authors, there are many talented artists and specialists working at AIC. Their work has been highly acclaimed in the animation industry worldwide.

The authors' representative work

Hiroyuki Kitazume
Picture Director on "ZZ Gundam"
Picture Director on "Megazone 23, Part 3"
Director and character designer on
all six installments of "Moldiver"

Matsuri Okuda
Director and character designer on
"Havenly Wars Shurato"
Director and character designer on
"Legend of Galactic Heroes"
Key drawings for "The Hakkenden"

Akihiro Izumi
Key drawings for "Silent M_bius"
Key drawings for "The Hakkenden"
Key drawings for "Ah! My Goddess"

Assistance:
Anime Spot and Studio BIHOU

**Addresses of AIC
and Yoyogi Animation Gakuin**

AIC
AIC Digital Bldg.
3-19-9 Nakamura Kita,
Nerima-ku, Tokyo 176-0023
Japan

Yoyogi Animation Gakuin
1-20-3 Yoyogi,
Shibuya-ku, Tokyo 151-0053
Japan

Upon Reading This Book

It looks like there are quite a few people out there who want to become an animator or who want to work in animation production. In fact, not a day goes by that a cartoon is not shown on television, and in Japan, animations get higher audience ratings than dramas starring popular actors. It is no wonder that people want to try doing it themselves. Nonetheless, compared to the large number of amateur cartoonists out there, as seen in the flourishing comic market, the number of amateur animators and amateur animation artists has just recently become quite substantial.

There could be several reasons for this. One reason could be the prevalence of secrecy in animation production. Another reason could be the lack of opportunities for amateurs to present their works.

This book was written in the hope that it would be of some help to amateurs who are interested in animation production and people who want to be an animator. Animation production should be fun, even if you do not know the minute details of the techniques used by professionals. We would like nothing better than to have even one person who reads this book learn how much fun animation production is and contemplate it as a career choice. We are also confident that the basic knowledge of animation contained in this book will help people create comics filled with film-like qualities. We hope that those who read this book, including those striving to become a next-generation comic book author, will use this book as a stepping stone to becoming a creator.

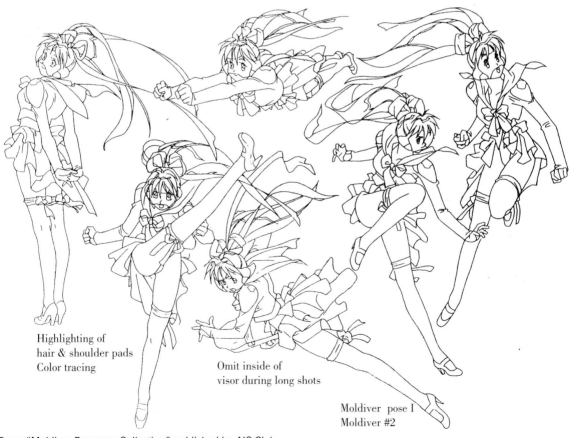

Highlighting of
hair & shoulder pads
Color tracing

Omit inside of
visor during long shots

Moldiver pose I
Moldiver #2

From "Moldiver Resource Collection" published by AIC Club

Animation Process

This is how animations are made.

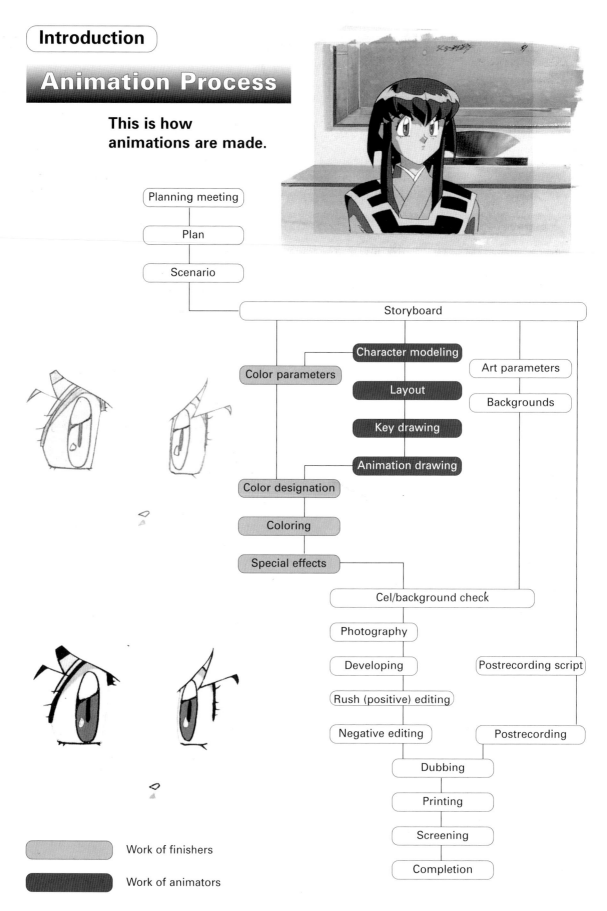

Planning meeting

Plan

Scenario

Storyboard

Character modeling

Color parameters

Art parameters

Layout

Backgrounds

Key drawing

Animation drawing

Color designation

Coloring

Special effects

Cel/background check

Photography

Developing

Postrecording script

Rush (positive) editing

Negative editing

Postrecording

Dubbing

Printing

Screening

Completion

Work of finishers

Work of animators

Animation production process

How are cel animations made? The process can be divided into three major areas: planning, production of materials (pictures and sounds) and turning the completed materials into a film. The process most familiar to the general public is the production of materials, but there are many other people that take part in the production of an animation. A total of more than 100 people are involved in the production of a 30-minute animation.

In Japan, this process is followed in almost all cases when producing a cel animation, but the process may differ depending on the country or production company. For instance, in the United States or Europe, the sounds may be recorded first and the pictures drawn to fit the sounds (this is called pre-scoring). The order may be different, but both approaches will include the same stages. And the stages will pretty much involve the same tasks.

Planning meeting
Important people get together to talk about whether the animation will be for TV or video, whether it will be 30 minutes or an hour, and what kind of story it will have.

Plan
The things decided at the planning meeting are put in writing to be presented to sponsors, TV stations, sellers, etc.

Scenario
The plan is turned into a script so that there is logical development.

Storyboard
This is a scenario with pictures created based on the scenario to determine how to construct scenes.

Postrecording script
This is a script for voice actors that contains the lines taken from the storyboard.

Character modeling
Creation of character blueprint for animators.

Art parameters
Blueprint of background and buildings, etc., for animators.

Layout
Drawing of actual scene compositions in full size.

Key drawing
Only points for moving of characters are drawn.

Animation drawing
Character movements are completed based on key drawings.

Backgrounds
Drawing of backgrounds based on the layout.

Color designation
Instructions regarding which colors will be drawn where are written on cels.

Coloring
Color is added to each cel.

Special effects
Special painting with an airbrush, etc.

Cel/background check
Completed cels and backgrounds are overlapped to check for errors.

Photography
Cels and backgrounds are photographed at the direction of animators.

Developing
The film is developed.

Rush (positive) editing
Prints are edited and time/timing are adjusted.

Postrecording
Voice actors are recorded speaking their lines in sync with the animation.

Negative editing
The same editing is done with the negative (original) as was done with the positive.

Dubbing
Finished sounds are added to the edited negative.

Printing
Film for showing is printed. In the case of television, it is put on video.

Screening
Important people preview the completed film to evaluate it.

Description of work involved in animation production

1 Scenario

Written by a scenario writer based on the theme decided upon in the planning stage. The sentences describe each part in a cinematic style, while conveying the intent of the author. Character movements, settings and spoken lines are then divided into scenes. The scenario acts as the foundation for production of the animation.

2 Presentation (storyboard)

The storyboard specialists, working under the guidance of the director, draw a storyboard based on the scenario. The storyboard acts as a blueprint during the remainder of the project. The storyboard includes the scenes, spoken lines, sound effects, number of seconds and other information. The people in all of the production sections will be able to understand it at a glance.

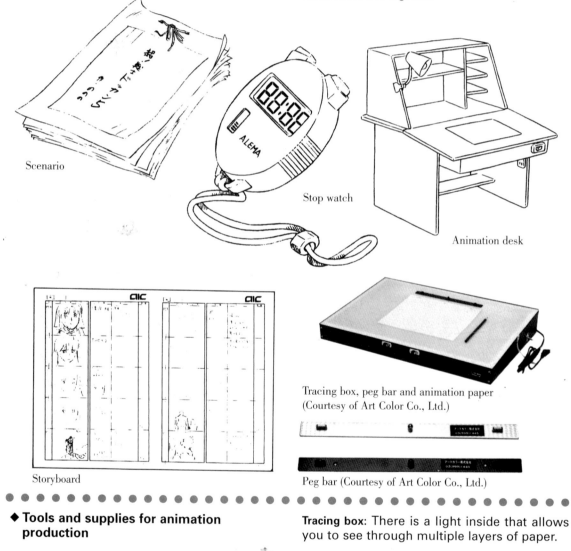

Scenario

Stop watch

Animation desk

Tracing box, peg bar and animation paper
(Courtesy of Art Color Co., Ltd.)

Peg bar (Courtesy of Art Color Co., Ltd.)

Storyboard

◆ **Tools and supplies for animation production**

Storyboard paper: This paper is printed in a form that makes it easy to create the storyboard, which is a scenario with pictures.

Stop watch: Used by animators and directors to measure the length of character movements and determine timing.

Tracing box: There is a light inside that allows you to see through multiple layers of paper.

Animation desk: A desk designed specifically for drawing. A portion of the top surface is embedded with frosted glass with a fluorescent lamp below it. This makes it easier to see through paper. There is a desk for finishing work that has no incline and different shaped shelves.

3 | Drawing

The animator's job is very diverse. First, the animator must design and model characters at the same time that the animation is being planned and the scenario is being written. Designing involves coming up with characters. Modeling involves putting together a collection of facial expressions and poses for later reference to make the animator's job easier. When the storyboard has been completed, the animator creates a layout based on the storyboard.

Layout work is the process of deftly fitting the source of the pictures that will actually appear on television within the frame representing the television screen printed on layout paper. The presentation is then checked. When the go-ahead is given, character drawings and movements are gradually completed based on the layout: key drawings, proofing of key drawings, animation drawings and proofing of animation drawings. When the key drawings are drawn, a time sheet indicating the timing of character movements is filled in.

Mr. Hiroyuki Kitazume drawing

Layout paper

Animation paper

Time sheet

Production Division

This section is at the center of animation production. It comes up with a budget, brings together the necessary staff, draws up a schedule, bridges the gap between sections and manages the animation. It plays an important role. Without it, the work would not get done.

Peg bars: These keep multiple sheets of animation paper or cels in position. They are used mainly by animators and finishers. They are also built into the photography table.

Layout paper: This paper has a film or television frame printed on it to make composing a scene easier.

Animation paper: Paper designed specifically for drawing animations. It has holes for placing it on the peg bar.

Time sheet: A table that contains information about how a moving picture will appear on television and the timing of the presentation.

4 | Finish

There are also many finishing tasks. First, you have to decide what colors to use after the animator has finished character modeling. You should think of the overall tone of the pictures and keep the backgrounds in mind. You then put all the selected colors on a color designation table so that none of the finishers makes a mistake.

Next, you designate what colors will be used on the animation drawing received from the animator. This task involves writing directly on the animation drawing what color should be used, since the same character may be colored differently depending on the scene.

When the above tasks have been completed, the pencil lines of the animation drawing are traced on cels, which are then colored with animation colors. Fog and gradation are called special effects. They are drawn with an airbrush. Completed cels are checked and if they pass they are sent for photography together with backgrounds.

Finishing-coloring using animation colors

Animation colors
(Courtesy of Art Color Co., Ltd.)

Cels

Airbrush

Stirring rod
(Courtesy of Art Color Co., Ltd.)

Tracing machine

Pen body & tips
(Courtesy of Art
Color Co., Ltd.)

Gloves (Courtesy of
Art Color Co., Ltd.)

◆Tools and supplies for animation production

Cel: A clear acetate sheet that is the same shape as animation paper. Characters that will appear on television are drawn on cels and colored.

Tracing machine: A machine that copies pencil lines on animation drawings to cels. Lines drawn with colored pencils are not copied.

Animation colors: Paints designed specifically for coloring cels. They are water-based, but they are water-resistant when dry.

Stirring rod: A rod used to mix animation colors that have separated.

Airbrush: Used to draw fog and gradations.

Pen: Used for color tracing and other tasks during preparation of cels.

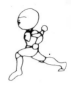

5 | Backgrounds

There are a number of background-related tasks. First, art parameters, which determine the world view of an animated film, are created. They are designed to standardize the tone, touch and settings. The layouts received from the animator are now called key background drawings. The individual backgrounds that will appear on television are drawn based on the key background drawings. Backgrounds are drawn on regular drawing paper using regular poster colors. Airbrushes are also used quite a bit, but gradations, blur, clouds, light hitting an object and other effects are drawn by hand. The completed backgrounds are sent for photography together with cels after being checked by the art director.

6 | Photography

Completed cels and backgrounds are overlapped and photographed. They are photographed on a line drawing table (photography table), a camera setup designed specifically for photographing animations, one frame at a time as directed by the animator. The table on which the cels and backgrounds are placed and the camera can both be manipulated to create a variety of effects.

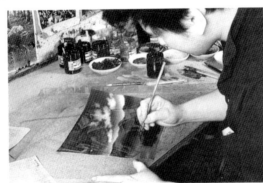

Drawing a background

Line drawing table

Poster colors
(Courtesy of Art Color Co., Ltd.)

Photography

Poster colors: Used for drawing backgrounds. They are somewhat water-resistant after drying. They can be extremely powerful tools, depending on your technique. For instance, if you are quick, they can be painted over.

Gloves: Used to prevent oil on your hands from getting on cels when you touch them.

Line drawing table (photography table): A table used for photographing animations. The camera faces down perpendicular to the table, where cels and backgrounds are placed for photographing. The table can be minutely manipulated in a variety of ways, including rotation and sliding. The camera can be moved up and down to accommodate both wide and narrow shots (these are controlled by a computer). The shutter is activated by a foot pedal.

It is our impression that there are a lot of people who like only the pictures in animations. Such people like the characters rather than the animations themselves. There is nothing wrong with this, but we cannot help but think that so much more fun could be had if people would take the next step. Let's learn the basic terms related to images in order to get a feel for creating a television picture and not just a picture on paper.

What is the size and at what angle is it seen? (Picture types)

Size

You begin with an awareness of the existence of the camera. The television picture frame is something you do not have to worry about if you are just drawing pictures. All images, including animated images, fit within this frame. The shape of the frame is fixed. Consequently, the size of the character in the picture can be changed to create a desired effect. When thinking of the composition of a picture, you must be aware of the picture frame and the size of the character within the picture. How well this is done affects the presentation. Types of sizes are shown on the following page.

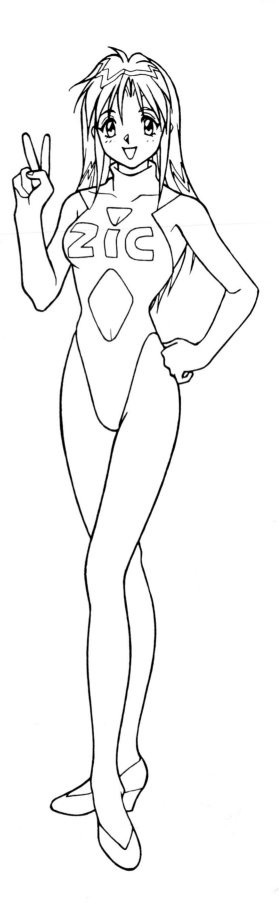

Types of sizes

1. Long shot: The character is shot from a distance. Small movements are hard to see, let alone facial expressions, but it is easy to grasp speed and distance when the character is made to walk or run.

4 Waist shot: It is easy to present the movement of the hands and arms. The lower body cannot be seen, but the state of the lower body can probably be figured out from that of the upper body.

2. Full body shot: The entire body of the character just barely fits within the frame. It is easy to express exaggerated gestures without changing the location of the character much.

5. Bust shot: Good for showing both the facial expression of the character and what is going on around the character. In television animations, this shot is often used when a character is just talking.

3. Medium shot: The character is bigger than in a full body shot. The facial expression of the character can be distinguished if the head is large. A shoulder bag will fit within the frame.

6. Full face shot: The face takes up the entire frame. This shot is often used when you want to emphasize the facial expression of the character.

7. Close-up shot: You are so close that the entire face does not fit within the frame. This shot is often used to create a powerful image that is almost palpable.

Position and angle

What angle do you use when you draw a character? I bet many of you draw a character as seen from the left of center. And I bet people who are used to drawing a character from this angle can complete a picture in no time. But can you draw a picture of a character from above looking down or from below looking up? Can you draw with perfect ease a character as seen from the left or from the right? Practice until you can draw a character from a variety of positions and a variety of angles, as if the camera were moving around the character.

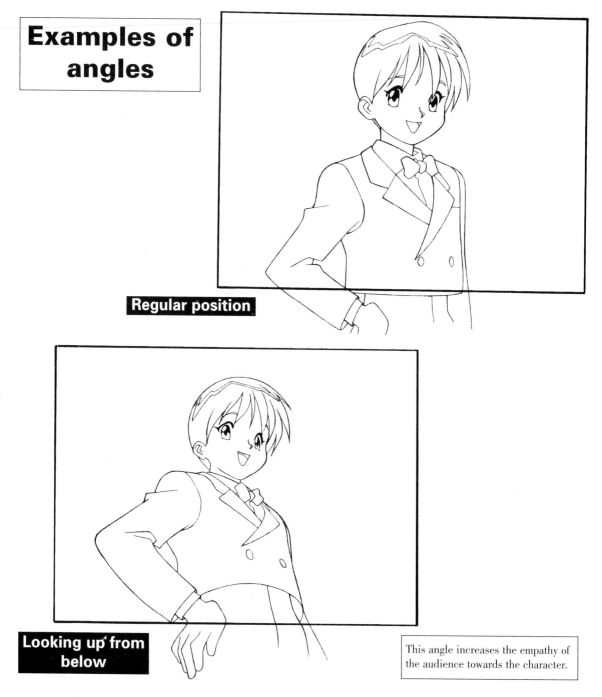

Examples of angles

Regular position

Looking up from below

This angle increases the empathy of the audience towards the character.

14

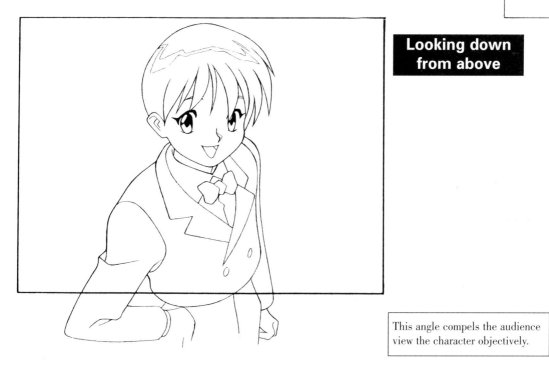

This angle compels the audience view the character objectively.

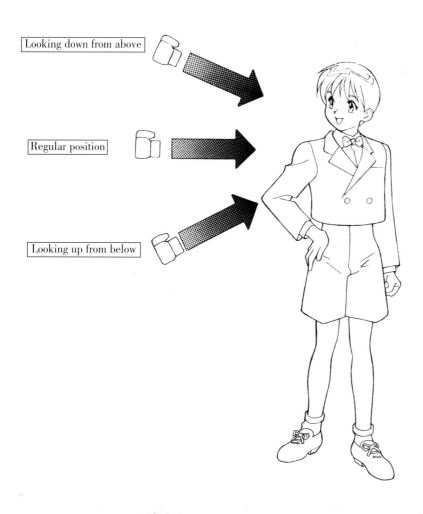

Looking down from above

Regular position

Looking up from below

How long will actions appear on screen?

Length unit (cut)

A cut can be thought of as one frame in a manga. It can also be thought of as each individual picture in a film. A cut differs from frames in manga in two ways: the shape of the frame is fixed (a rectangle with a fixed aspect ratio) and only one cut can be shown to viewers at a time. In the case of manga, you think of how best to divide a page into frames to create the desired effect, but in the case of films, you think of how to create the desired effect by moving the camera or using character movement within a cut. In addition, it is left up to the reader just how fast each frame in a manga is read, but the length of each cut in a film is determined by the director and presented to viewers. As such, the length (seconds) of each cut must be determined based on careful calculation before being joined with other cuts.

Relationship between time/scene/cut/picture(Example)

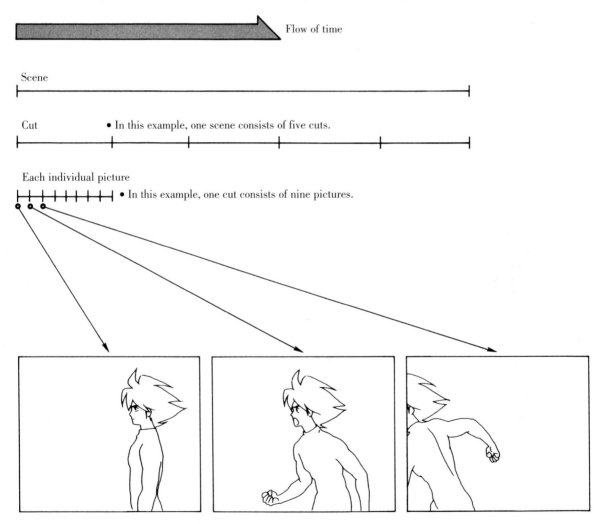

You create a story by dividing single scenes into cuts with some dramatic intent. Each scene is made up of several cuts. Each cut contains a series of pictures that depicts some movement.

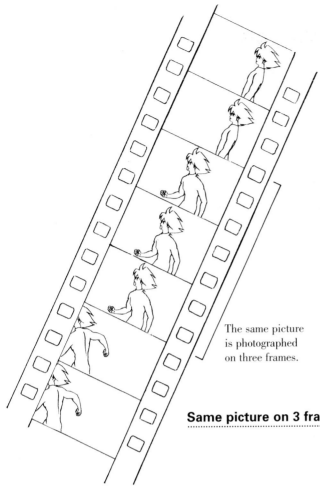

In the case of film used for photographing animations, approximately 24 frames equal one second of animation (by comparison, in the case of video signals recorded on magnetic tape, approximately 30 frames equal one second of video). In the case of filming of an actual event, the image in each frame is slightly different, but in the case of television animations, since each picture has to be drawn by hand, making it a very time-consuming task, the same picture is usually photographed on three frames. This reduces the production time and cost of animations and allows for addition of unique modulation to movement. This unique modulation is what distinguishes Japanese cel animations from other types of animations.

The same picture is photographed on three frames.

Same picture on 3 frames = 8 pictures per second (24 = 3 X 8)

Why Do the Pictures Drawn by Animators Move?

 I am sure that you have all experienced the lingering light you see when you look at a fluorescent light or other source of light for a short time and then look away. The image is burned onto your eyes and does not disappear right away. This is called an afterimage. All films including animated films are based on this phenomenon (Note 1). In animations, since colored characters move, pictures should be drawn in clumps of colors (Note 2).

Afterimages
Utilizing optical illusion

Note 1 For instance, when the warning lights at a railroad crossing flash, it looks like the red lamp is moving back and forth. It is not actually moving. It is simply a repetition of the lamp on one side being turned off when the lamp on the other side is turned on, but to us it looks like the light is moving. This is the principle behind animation (and all other film). An image (a picture) disappears and a similar image (a different picture) appears, but because of afterimages, the previous picture remains faintly in the eye. The previous picture slowly fades away and the next picture becomes clear. All of this happens in an instant. If the shape of an object is different, it will look like the object has changed shape. If the location of the object is different, it will look like the object has moved. Since the two processes of disappearing and appearing occur quickly, to humans it looks like movement.

Note 2 A tree, for instance, should be a combination of a clump of green and a brown cylinder. This concept differs from a "Manga" style drawing, which stresses linework to create an object's shape. It is not the contour lines of the face or clothes drawn with a pen or pencil that are important. It is actually the area (volume) of the colors painted within those contour lines that is important. These clumps of color stand next to the shape of a face or next to the shape of a machine and they change moment by moment. These changes in clumps of colors look like movement thanks to the afterimage phenomenon.

How to Make Drawn Objects Move

The following can be used to "move" pictures based on the afterimage phenomenon.

1. Movement
2. Transformation
3. Enlargement and reduction

These can be used separately or in combination to make animation pictures move. When attempting to make an animation picture move, what the beginner has to be most careful of is the sense of "depth." This could also be referred to as "understanding space." During this process, a three-dimensional object is depicted in two dimensions. Here the distance between the camera (vantage point) and the subject is important. Draw an object in terms of what direction it is facing and how it looks in relation to the vantage point.

1 Movement

When an object changes position within the picture without changing shape, it means the distance between it and the camera remains constant.

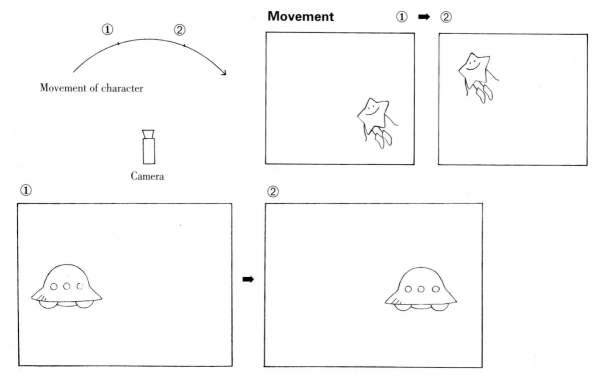

2 Transformation

There are two types of transformation. One is where the object itself changes shape and the other is where an object changes shape two-dimensionally because the viewing angle has changed, even though the object is the same. The familiar scene in which a character looks back is an example of the latter type of transformation, as shown in the figure.

Transformation ① ➡ ②

Movement of character

Camera

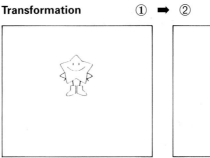

①

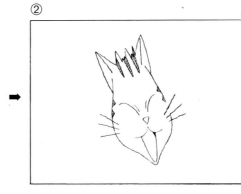

②

3 Enlargement and reduction

This is the only way to express depth. Since an object far away will be small and one close will be big, an object can be made to move toward or away from the camera by changing the size of the object.

Enlargement ① ➡ ②

①

② ◯
Movement of character

② ◯

Camera

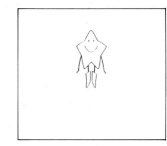

The Oozora family's house
(facing front entrance)

From "Moldiver Resource Collection" published by AIC Club

Mirai's room
2nd manuscript

There is a
window here

To veranda

Chapter 1
Drawing Animation Pictures

From "Moldiver Resource Collection" published by AIC Club

1. Decide What You are Going to Draw

◆ Create an image in your head.
◆ Decide what you are going to draw before you draw it.

<Pose / Camera angle>

It is certainly fun to go wherever your hand takes you when drawing, but it is important to plan ahead when drawing for animations. You should have a clear idea of what the character is like before you start drawing.

Try to create characters that can be described by the people who see them.

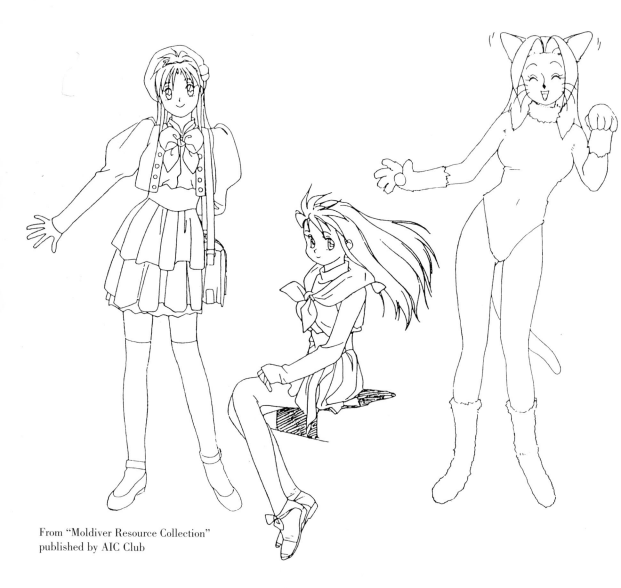

From "Moldiver Resource Collection"
published by AIC Club

◆ Make your characters distinct

<Character table>

1. Age?	Grade school, high school, young, middle-aged, elderly, etc.	
2. Gender?	Male, female	
3. Personality?	Cheerful, gloomy, thoughtless, high strung, etc.	
4. Features?	Foreign, old Japan, rich, rebellious, etc.	
5. Stature?	Tall, thin, muscular, etc.	
6. Clothes?	Formal, casual, uniform, etc.	

◆ Determine the size within the paper.

Have you ever been drawing a picture without giving it much thought and suddenly found that the legs do not fit on the page? If you do not plan ahead, all the time you put into a drawing could very well go down the drain. There is always a suitable way to present what you are trying to express in a picture. First, think about what size is necessary.

All of what you draw on paper will not appear on the screen. You have to be careful, because only the portion of the picture within a frame placed at a fixed position on the animation paper will appear on the screen.

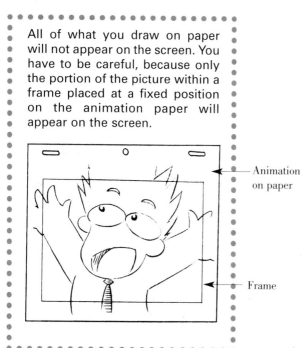

— Animation on paper

— Frame

① You can best see how the character is holding the card.

② You get a good idea of the card and the character.

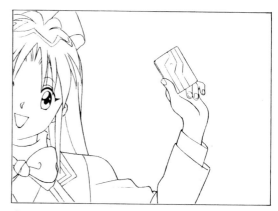

③ You want the card to be seen and the character is secondary.

<Pencil techniques>

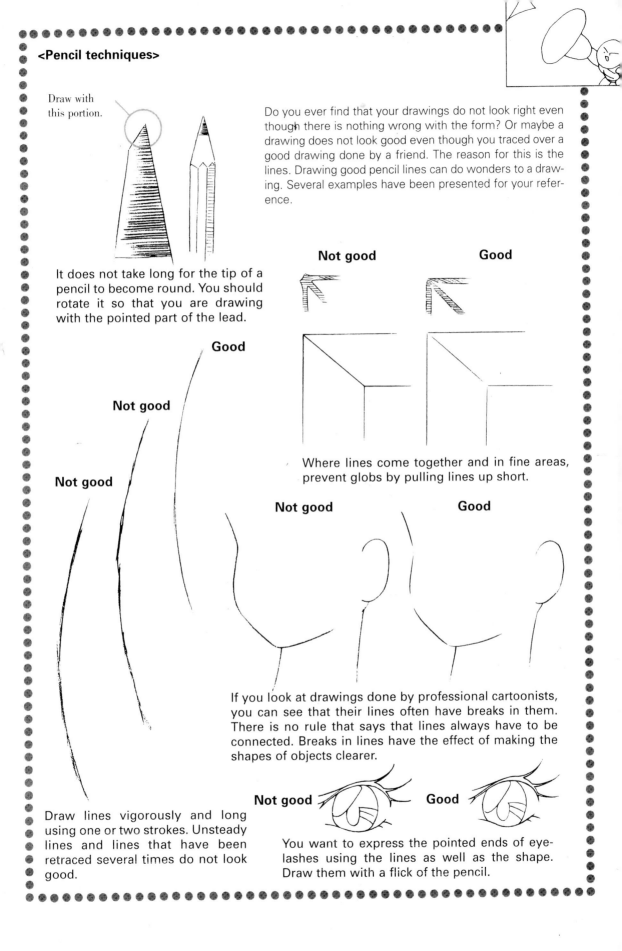

Draw with this portion.

Do you ever find that your drawings do not look right even though there is nothing wrong with the form? Or maybe a drawing does not look good even though you traced over a good drawing done by a friend. The reason for this is the lines. Drawing good pencil lines can do wonders to a drawing. Several examples have been presented for your reference.

It does not take long for the tip of a pencil to become round. You should rotate it so that you are drawing with the pointed part of the lead.

Not good **Good**

Where lines come together and in fine areas, prevent globs by pulling lines up short.

Good

Not good

Not good

Not good **Good**

If you look at drawings done by professional cartoonists, you can see that their lines often have breaks in them. There is no rule that says that lines always have to be connected. Breaks in lines have the effect of making the shapes of objects clearer.

Not good **Good**

Draw lines vigorously and long using one or two strokes. Unsteady lines and lines that have been retraced several times do not look good.

You want to express the pointed ends of eyelashes using the lines as well as the shape. Draw them with a flick of the pencil.

2. Do Not Make a Clean Copy Right Away

Process 1 Draw outline

Lightly draw a general outline. Decide on the pose of the character. The lines at this stage are not yet the "correct" lines. These lines will be erased later, so there is no need whatsoever to draw them carefully. Be bold!

A. In addition to characters, how you leave space open is important to a good-looking picture.
B. Lines are light. These lines will only be used as a reference as you draw your picture.

Draw the character in proportion based on the character parameters (balance between the size of the head and body).

Process

Compare the main parts
(balance the head and shoulders, etc.)

Gradually make the shapes a little more concrete. When doing so, compare the size and length of the parts to see if they are well balanced.

A. Think about the flow of the center of the body.
B. Confirm the position and tilt of both shoulders and make sure the pose is the one you intended to draw.

Compare the size of the head and the width of the shoulders.

Process ⟨**3**⟩ Arrange parts (eyes, nose, mouth, etc.)

As with the overall character, do not start drawing the face by drawing a bold mouth or eyes. First, decide where the main parts like the eyes, nose, mouth and ears will go.

Where you place the eyes, nose, mouth and ears determines the direction and inclination of the face. The same thing goes for other parts and accessories on the body.

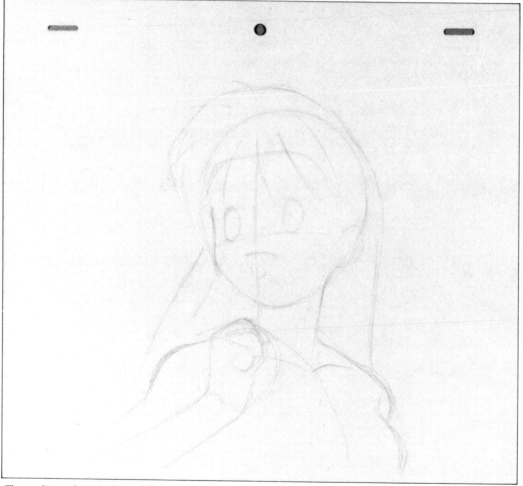

The quality and atmosphere of the picture can be judged at this stage.
If you do not like what you see, now is the time to fix it.

Process 4 Begin to add fine details

Add more details to the character. Draw the expression of the face and hands and add clothing. This concludes the outline.

A. The curve of the cheeks is a delicate area. Even a very slight difference can change the character, making it fatter or thinner.

B. Pay particular attention to the size of the eyes. Think of both the iris and the whites of the eyes. Make sure both eyes point in the same direction.

C. You can prevent the hands from looking bad by making sure the fingers are not parallel.

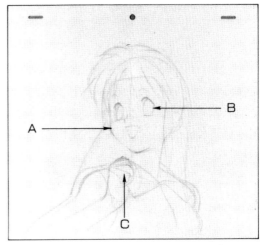

Incorrect: The left eye is too low and it has lost its shape. If you think it does not look right, do not hesitate to draw it again.

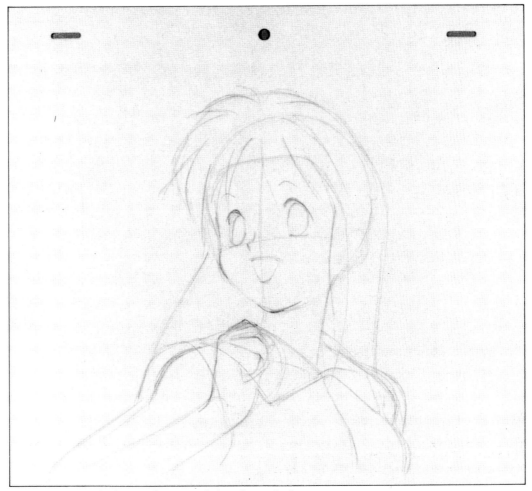

Do not look at just the lines. Balance it with the volume of color.

Facial Expressions

From "Moldiver Resource Collection" published by AIC Club

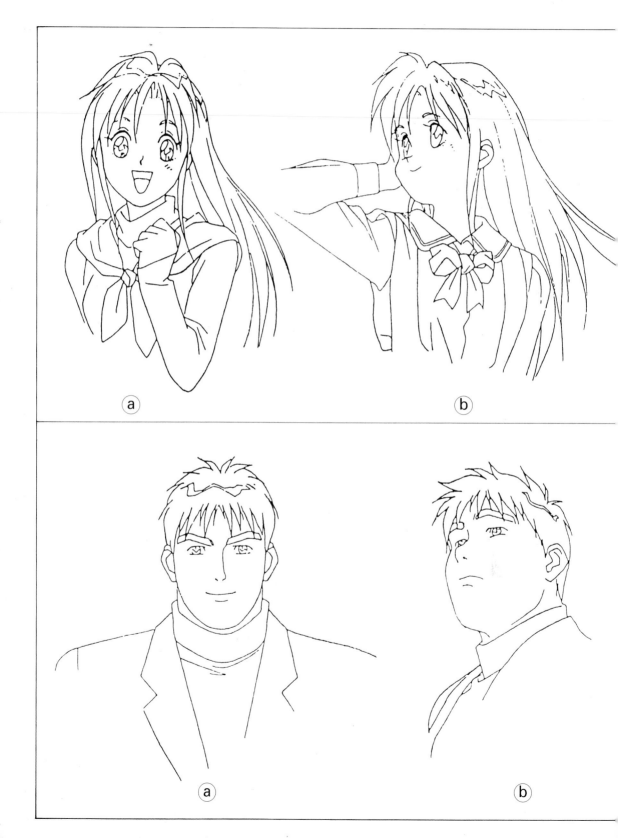

ⓐ The character's expression.

ⓑ The character is looking up. The eyebrows, eyes, nose and mouth are higher than usual. Be careful how you form the chin.

ⓒ Try drawing characters facing to the right sometimes rather than always to the left. Eyebrows are drawn like this when the character is perplexed.

ⓓ Try drawing characters from other angles as well. Discover how characters look in different situations.

ⓒ

ⓓ

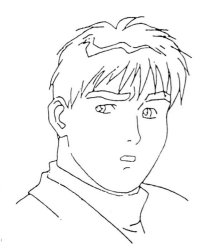

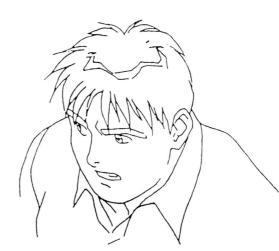

ⓒ

ⓓ

ⓐ The character's typical expression.
ⓑ How do the eyes look when a character laughs? How about the eyebrows?
 Are the eyes and eyebrows farther apart? Note the shape of the mouth.
ⓒ Note the height of the right and left eyes. The right and left shoulders are
 also inclined, so their height is different.
ⓓ Be bold and try to find interesting expressions.

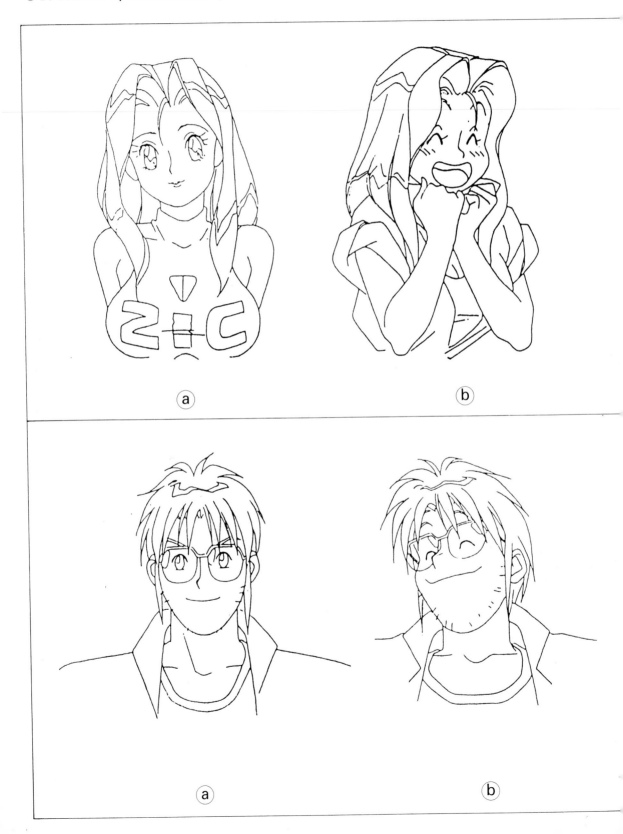

From "Moldiver Resource Collection" published by AIC Club

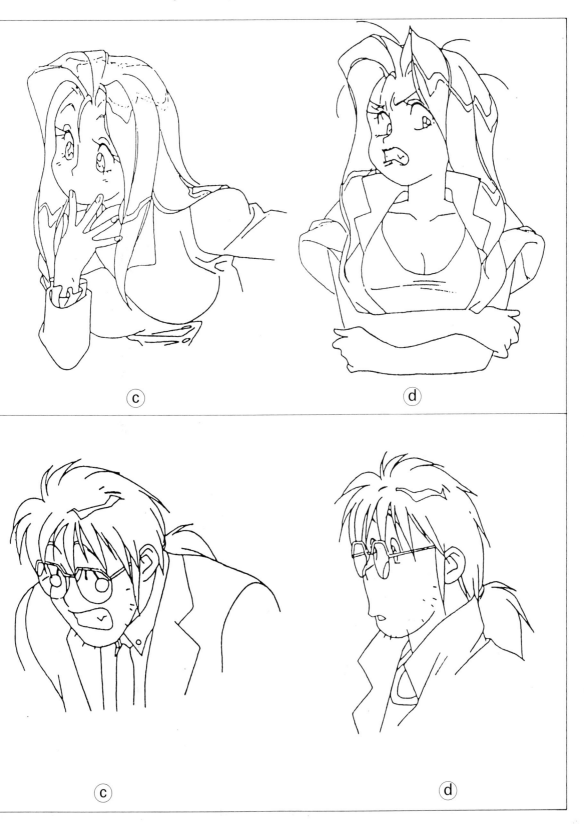

ⓐ The character's typical expression.
ⓑ Draw the side view of the face so that it looks like the same character as seen from the front.
ⓒ A different type of laugh. Like a laugh of embarrassment.
ⓓ Draw a surprised face like this. Note that the eyes and eyebrows are far apart.

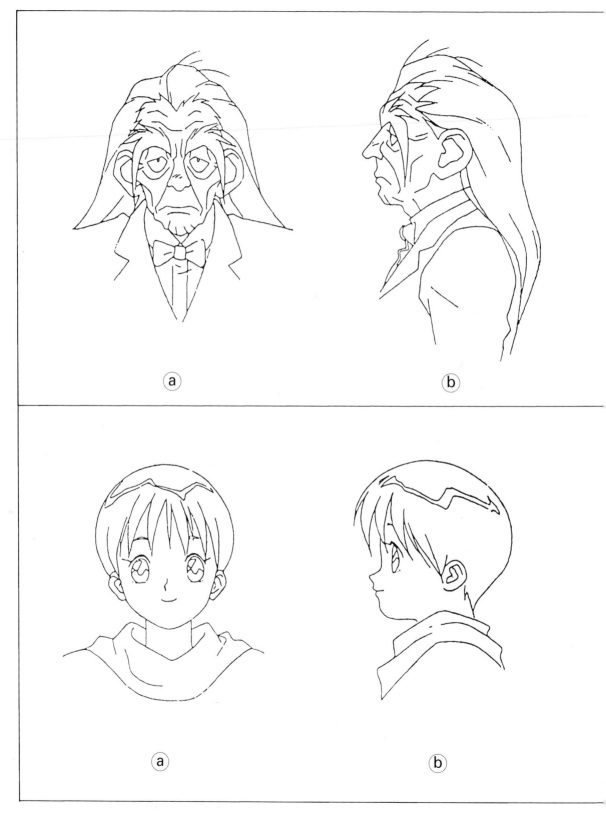

ⓐ

ⓑ

ⓐ

ⓑ

From "Moldiver Resource Collection" published by AIC Club

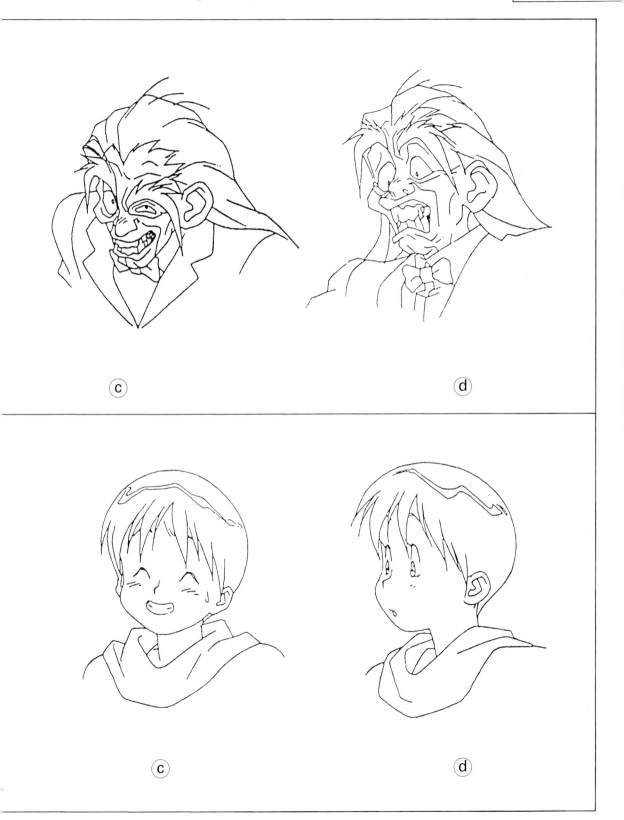

ⓒ ⓓ

ⓒ ⓓ

3. Put Lines in Order and Make the Shape Clear

Process 〈**5**〉 Find extra lines and incorrect lines

Continue to draw necessary lines and shapes. You may feel like the first lines you drew are starting to get in the way, but do not erase them just yet. They will continue to act as a guide as you draw.

It appears that the lines at the locations indicated are no longer necessary, but this is not true.

- The lines at location ① are necessary to make the hair look more like hair.

- The lines at location ② are necessary for thinking about the sags and wrinkles of clothes.

- The lines at location ③ are necessary to confirm the width of the chest.

The overall image is becoming clearer. From here on in, as you draw look for the lines that you will keep.

Process **6** Carefully draw the fine areas

After you have finished the general form, review the fine areas again. The overall appearance of the picture will only be one-tenth of its potential if you do the fine areas halfheartedly.

Be particularly careful with the areas indicated. Oddly enough, people tend to look at these fine areas. The eyes and mouth affect the expression and personality of the character.

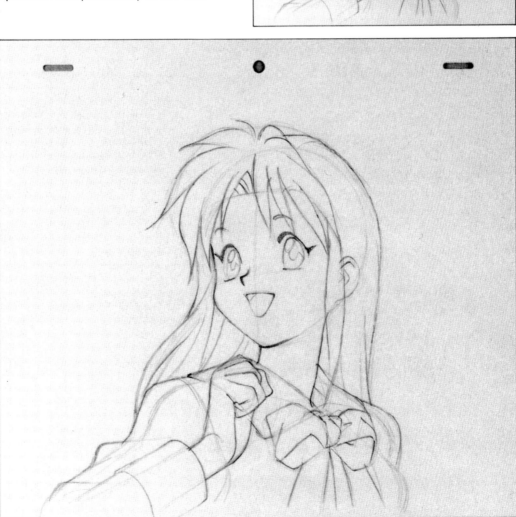

At this point, the picture is near completion. Make one final check for deviations in the form.

In the case of a normal picture

In the case of cel animation

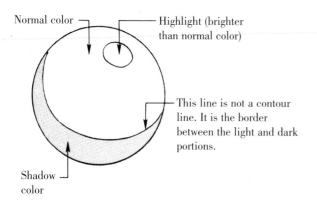

Normal color

Highlight (brighter than normal color)

This line is not a contour line. It is the border between the light and dark portions.

Shadow color

Process ⟨ 7 ⟩ Add shadows

Shadows in animations give characters, which are essentially two-dimensional, a three-dimensional feel. The unevenness of a picture is made easier to grasp depending on how the light hits a character. Shadows are indispensable for real, full-sized characters, considering the need to make a character's presence felt within the screen. Shadows are drawn with a colored pencil. This completes the rough sketch.

Gradation shadows are not used much in cel animations. There is a clear distinction between bright, normal and dark portions. For that reason the borders between the light and dark portions are extremely important.

Shadows are a pattern
This may be misleading, but animation shadows are often drawn in the form of a pattern. Nicely shaped shadows are sometimes drawn to make a picture look good after considering the direction of the light and the solid.

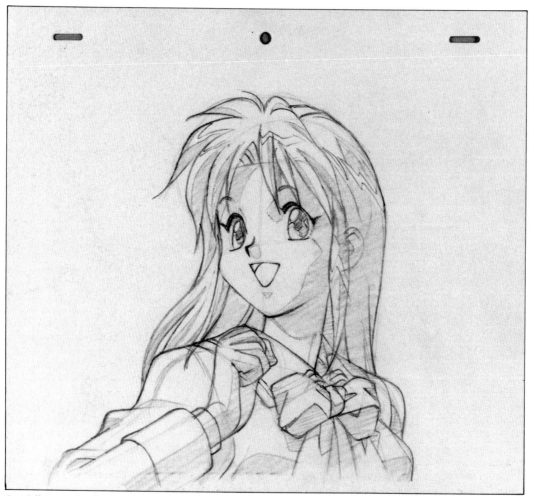

Carefully consider the unevenness of the solid when drawing.

Process <8> Make a clean copy

At this stage you tentatively finish your picture. In terms of the animation process, you will have completed a key drawing. Make a clean copy by tracing your picture with excess lines on a separate sheet of paper using a tracing box. Make minor corrections to lines and shadows as you trace without destroying the atmosphere of the lines and shapes in Process 7.

Completion of key drawing

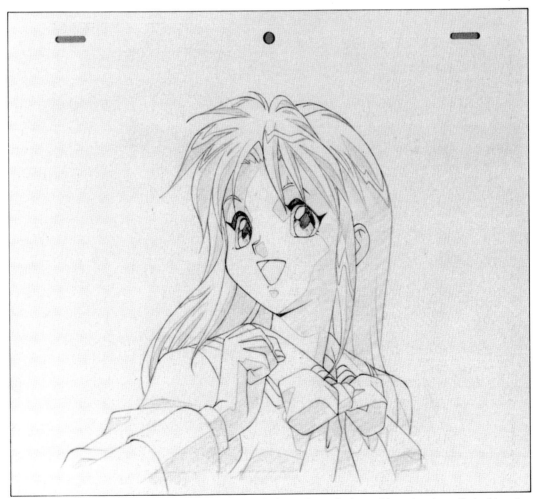

Spend plenty of time on the fine parts so they do not look sloppy. Draw shadows with a colored pencil. At this point, the picture does not have to be very colorful. You just have to be able to distinguish between light and dark .

4. Clean-up

The cleaning up at this stage differs from that in Process 8. Cleaning up at this stage is done to make a cel. Special lines are drawn during this clean-up. This drawing will be the source of the picture (cel image) that will actually appear on the television or theater screen. This clean-up is the final task of the animator.

Process Cleaning up contour lines

Start by cleaning up regular contour lines (called solid lines). Note the following six points when cleaning up solid lines.

1. Just like calligraphy or inking in manga, avoid retracing a line you have already drawn whenever possible.

2. Make the shade of all lines the same.

3. Draw lines in one stroke without hesitating.

4. When you draw one line by connecting two separate lines, make the point where they join as inconspicuous as possible. Raise your pencil like an airplane taking off and bring it down where the lines will join like an airplane landing.

5. There is no need to worry about the orientation of the paper on the desk. Move the paper to a position where it is easy to move your hand in the direction of the line you want to draw.

6. Be sure to exploit the accentuation and atmosphere of the lines in the picture drawn up to Process 8.

Clean up with the drawing from Process 8 underneath.

Example of clean-up done poorly

The lines are wavering and the smoothness of the cheeks is gone. Try drawing with brisk and smooth strokes.

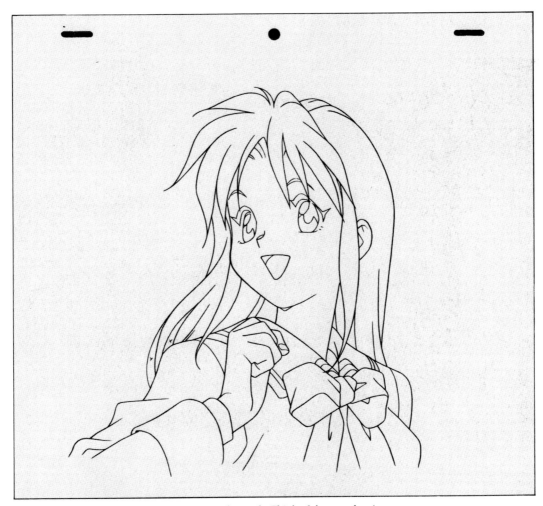

Do not think just about tracing the picture underneath. Think of the new drawing as a finished product. Keep checking how the new picture looks as you draw.

Process ⟨10⟩ Cleaning up shadows

You use a colored pencil when cleaning up shadows. Vermilion and other warm colors are often used. For the parts to be done in a dark color (shadow color), distinguish them from the other parts by coloring very lightly using the edge of the colored pencil. This completes the animation drawing.

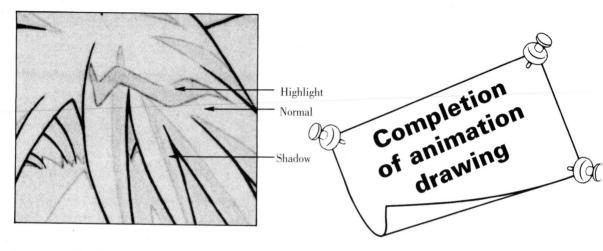

Highlight

Normal

Shadow

Completion of animation drawing

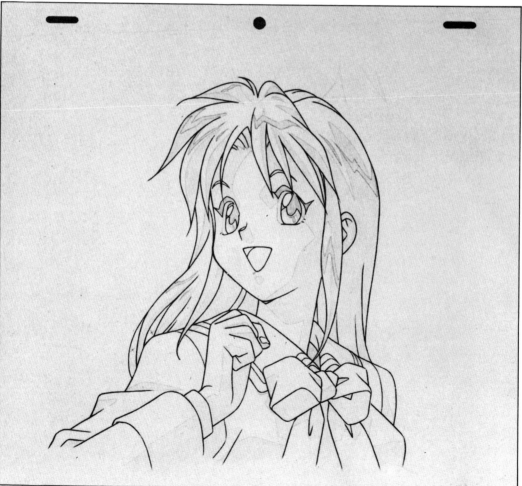

This is not the same as coloring a picture. Whatever you do, do not press down hard with the colored pencil. Think carefully about the fact that the picture will be colored later. The animation drawing is more colorful than the key drawing to make it easier to distinguish between colors when converting it to a cel.

Actual size

Hiroyuki Kitazume's Drawing Advice

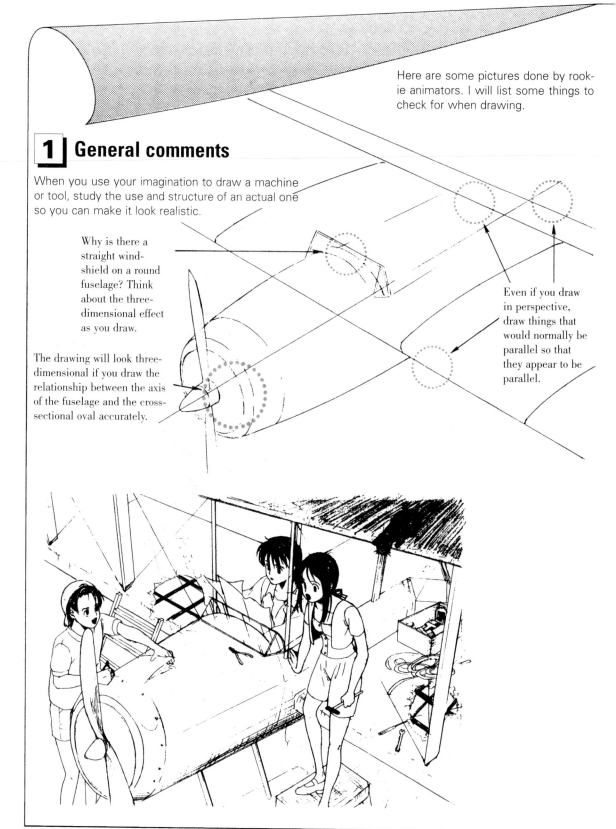

Here are some pictures done by rookie animators. I will list some things to check for when drawing.

1 General comments

When you use your imagination to draw a machine or tool, study the use and structure of an actual one so you can make it look realistic.

Why is there a straight windshield on a round fuselage? Think about the three-dimensional effect as you draw.

The drawing will look three-dimensional if you draw the relationship between the axis of the fuselage and the cross-sectional oval accurately.

Even if you draw in perspective, draw things that would normally be parallel so that they appear to be parallel.

2 Scenario

When drawing for fun, it is good to draw the surrounding background and not just the character. Practicing expressing a three-dimensional effect in the two-dimensional space of a drawing is a very good way to improve your drawing ability.

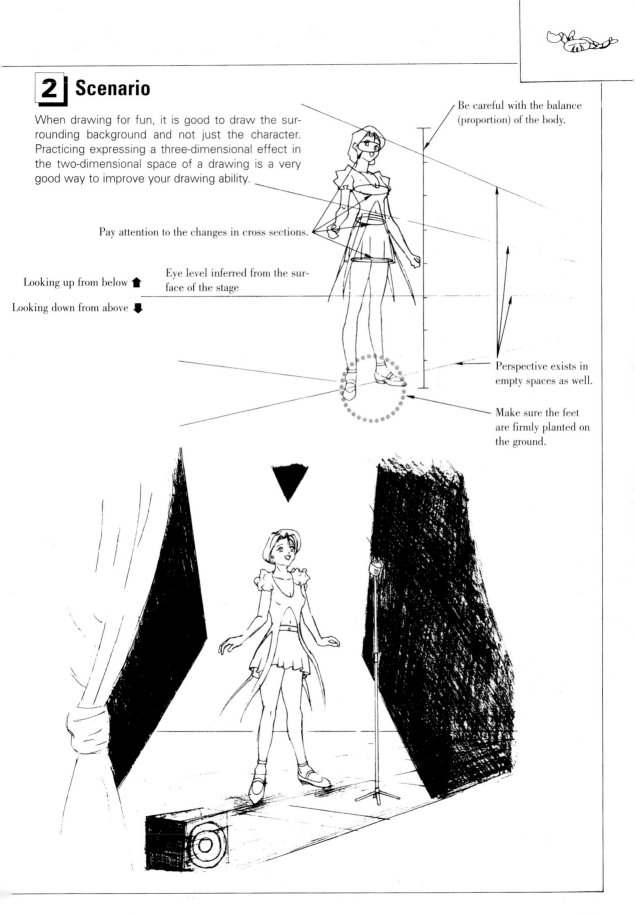

Be careful with the balance (proportion) of the body.

Pay attention to the changes in cross sections.

Looking up from below ⬆

Looking down from above ⬇

Eye level inferred from the surface of the stage

Perspective exists in empty spaces as well.

Make sure the feet are firmly planted on the ground.

Try drawing trees and other objects in a variety of ways to improve you range of expression.

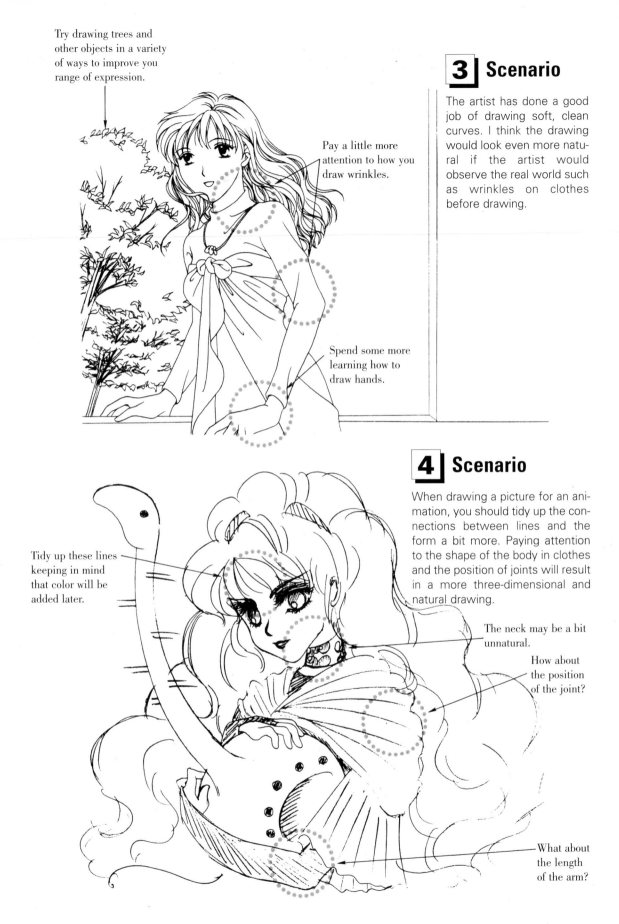

Pay a little more attention to how you draw wrinkles.

Spend some more learning how to draw hands.

Tidy up these lines keeping in mind that color will be added later.

The neck may be a bit unnatural.

How about the position of the joint?

What about the length of the arm?

3 | Scenario

The artist has done a good job of drawing soft, clean curves. I think the drawing would look even more natural if the artist would observe the real world such as wrinkles on clothes before drawing.

4 | Scenario

When drawing a picture for an animation, you should tidy up the connections between lines and the form a bit more. Paying attention to the shape of the body in clothes and the position of joints will result in a more three-dimensional and natural drawing.

Chapter 2
How to Add Colors to an Animation

From "Moldiver Resource Collection" published by AIC Club

Cel Animation Materials

Making a cel animation involves many processes, so you end up with an enormous number of drawings. These drawings eventually become one of two types of pictures, a cel or a background. It is the cels and backgrounds that are photographed. The cels and backgrounds needed for photographing are called photography materials or just plain materials. Animation (drawing), finishing and background (art) could be thought of as the sections that create these materials.

It takes the cooperation of many people to make an animation, but each task is done separately. As such, each section needs to have a good grasp of what is being done in the other sections in order to make a good animation.

Animation drawings are transferred to clear sheets made of acetate, which are then colored. This is the first time that the moving pictures have color.

Cels

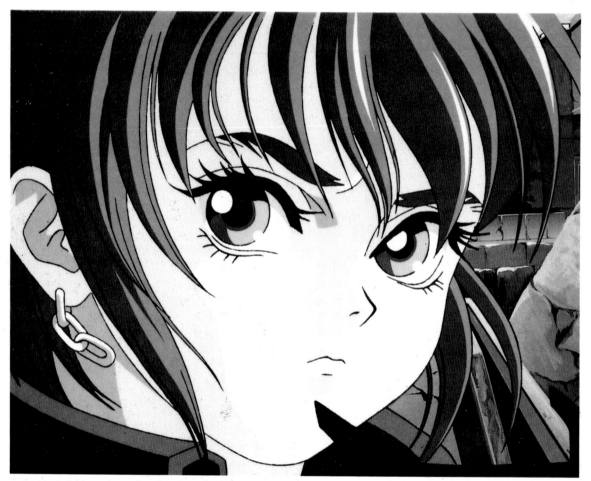

Animation picture seen on the television screen

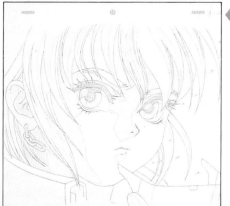

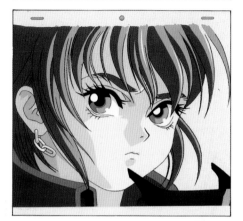

Animation drawings Movement is completed with a character consisting of only lines. They are drawn to fill in the space between key drawings. The lines on these drawings will be transferred to cels, so they must be drawn cleanly.

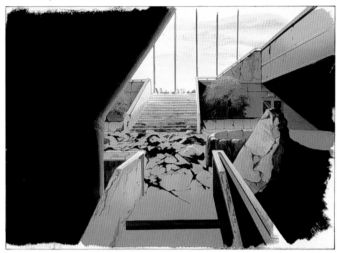

Backgrounds Rough drawings done by an animator are transferred to drawing paper and colored using poster colors. Unlike drawings of characters, contours are not drawn with black lines. Backgrounds are drawn with only color tones and the contrast between light and shade, like an oil painting.

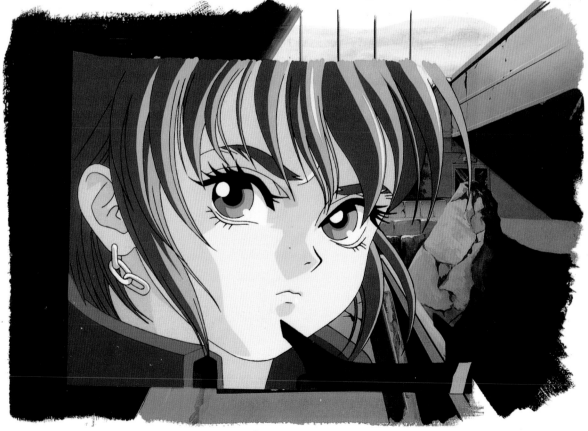

Animation drawing and background overlapped
This is what it looks like when a cel is placed on a background. They are photographed in this state.

49

Creating Cels (finishing)

Cels are what actually appear on the screen, so they have to be done carefully. Good drawings and movement done by the animator will not do you any good if the cels are dirty. Errors are minimized by proceeding systematically. As for coloring of cels, there are many different ways of going about it and all have to be done properly. Some tasks can only be done by someone who is used to doing them.

Example of color designation table

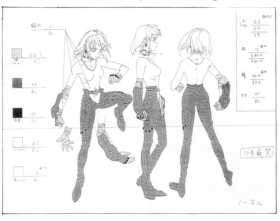

1. Color designation
Choosing what colors to use

In order to proceed systematically, you first have to designate what colors to use. You decide in advance what colors to use where and make a color designation table. You write the color numbers on the main animation drawings using a colored pen based on this color designation table.

Hair/eyebrows

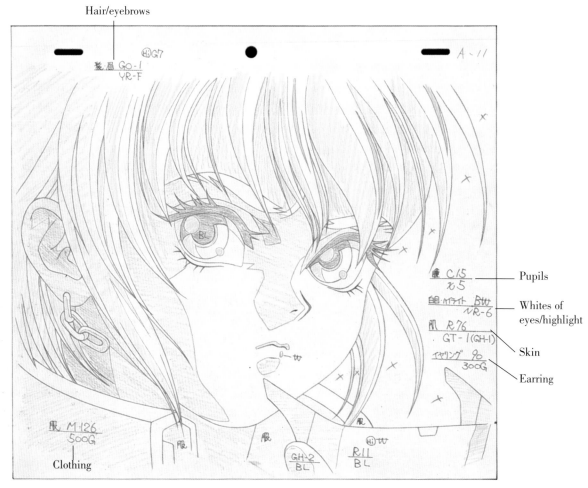

Pupils

Whites of eyes/highlight

Skin

Earring

Clothing

Animation drawing with color designations
Designate every little detail without making any mistakes.

The next step is to transfer the pencil drawings to cels using a tracing machine. A cel, carbon paper and an animation drawing are placed in that order on a mount called a carrier. The carbon paper is placed so that the side with the ink on it faces the cel. The carrier cover is closed and the carrier is run through the machine. The pencil lines on the animation drawing will appear on the back of the cel in ink.

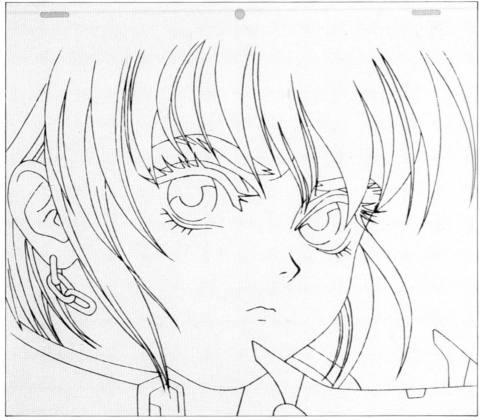

A cel created by the tracing machine.

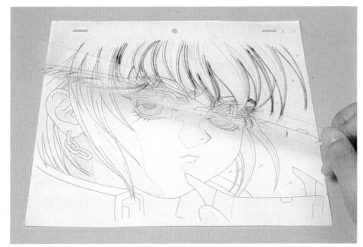

The tracing machine being operated.

You can see that the lines on the cel are blacker than the pencil lines.

Tracing

When you want to correct lines that the tracing machine did not transfer cleanly or when you want to draw contour lines in a color other than black, you use a pen and draw on the front of the cel by hand.

It is possible to transfer all the drawings this way. Aside from the fact that animations require tens of thousands of drawings, it is sometimes advantageous to trace by hand if you want to make one drawing especially clean.

In order to fix a cel with unclear lines, place the cel with unclear lines over its animation drawing and join the lines by tracing over the unclear parts with a pen. The trick is to pay attention to the boldness of the lines as you draw, as if you were inking in a manga drawing. For bold lines, draw the contour of the line itself using two lines and then fill in the space between the two lines with black.

The line may stand out like this when you are finished drawing it, but it will not show up when it is photographed, so there is no need to worry about it.

◆ **Difference between hand tracing and machine tracing**

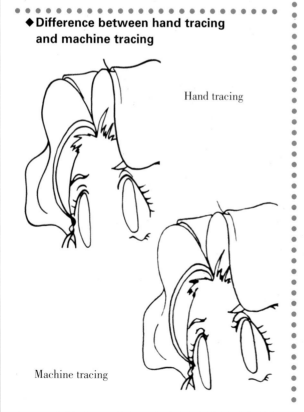

Hand tracing

Machine tracing

3. Color tracing —— Transferring colors other than black to cels

Hand trace lines using the actual colors that will be used for everything that does not have black contour lines like water, ice, fire and glass and borderlines between light colors and shadows even if the object is surrounded by a black contour. Shadows are not created using gradation. A characteristic of animations is the depiction of shadows by clearly separating the border between light and dark colors.

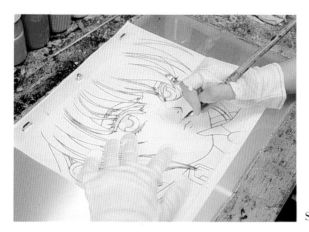

Someone performing the task of color tracing

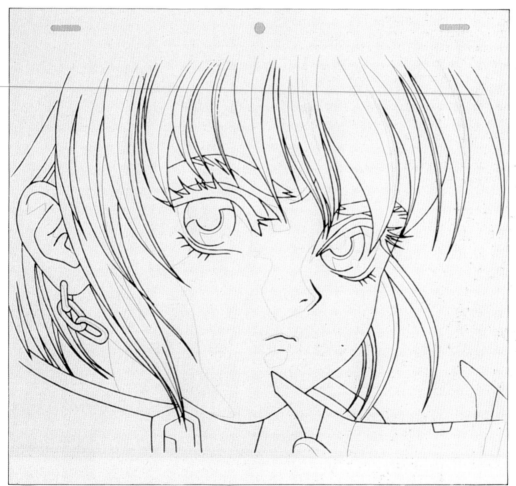

A cel that has undergone color tracing
Colors are traced on animation drawing lines that were drawn using colored pencils.

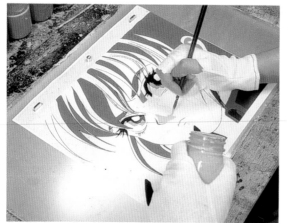

A cel being colored

Begin coloring the cel once the tracing of all contour lines, shadow borders and other lines have been completed. Coloring is the task of placing animation colors on the back of cels. The trick is to "place" paints on the cels rather than "paint" them on. Make sure that the colors are even.

When the animation colors are hard, dilute them by adding a little water to make them easier to apply. They are the right consistency if you can spread them on the cel lightly with a brush. Make sure that the paints do not become too thick.

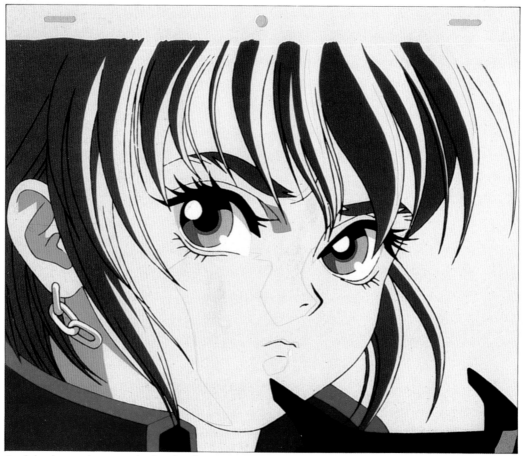

A cel that has not been completely colored yet

Always paint within the lines and make sure there are no gaps between colors. A good rule of thumb is to only cover half of the width of traced lines with animation colors.

You can erase animation colors if you wipe them off immediately. If you notice a mistake after they have dried, carefully scrape them off using a bamboo spatula.

The cel as seen from behind

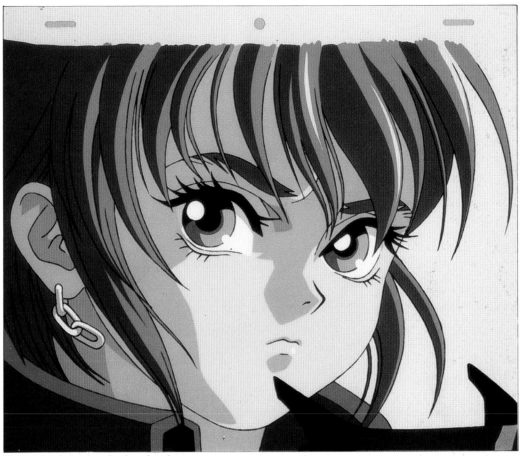

The cel has been completely colored

Cel animations sometimes require special effects that cannot be created by simply applying colors with a brush. In many such situations, an airbrush is used to create the desired effect. An airbrush is used to add gradations, to draw clouds, smoke and other objects that do not have a clear contour and to create a shining effect.

There are other extraordinary techniques for adding effects in addition to those created by an airbrush, including deliberately damaging a cel to cause a diffused reflection or adding a light color from above a cel, but these techniques are being done less and less by the special effects section as of late.

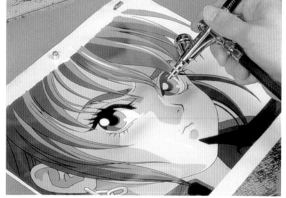

2

3

Examples of special effects created using an airbrush

1 Create flushed cheeks like these from the front of a cel.

2 Check to see that you can create the effect you want by practicing on a sheet of paper you do not need before airbrushing a cel. There is no turning back once you have applied a lot, so make adjustments as you go by applying it thinly and quickly over several blasts of paint.

3 This concludes the airbrushing task. Use airbrush effects sparingly, because if you use them too much on a cel it will stand out.

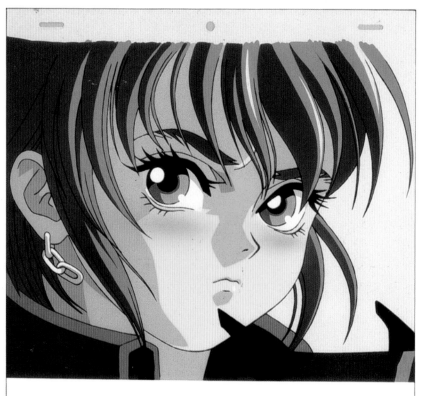

Completed cel

The light shining through clouds is expressed using an airbrush. The majority of the picture is done with a brush. The airbrush has been used to add spice to the picture.

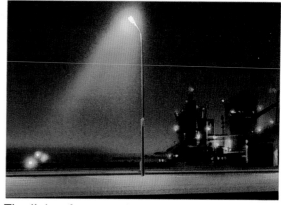

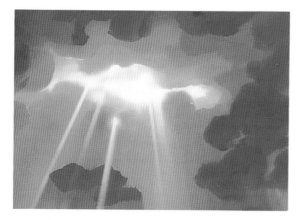

The light of a street lamp in the night sky was airbrushed in a sharp manner in order to indicate direction.

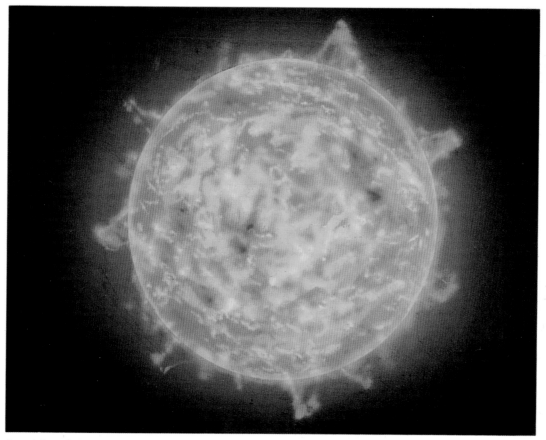

An airbrush is used to make the sun look realistic. You can express burning flames and brightness.

Painting Backgrounds

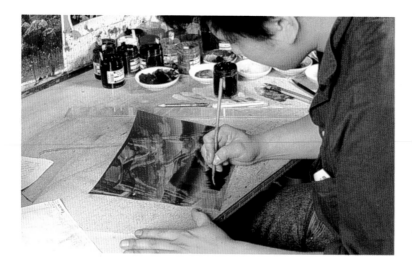

There is another material that appears on the screen in addition to cels: backgrounds. You may not notice them much as you follow a moving character on the screen, but the quality of background pictures affects the overall quality of scenes.

Characters are drawn in the "manga" style, but background pictures are similar to fine art. You think about hue, brightness and chroma as you paint. Unlike coloring within contour lines, you are more like a painter.

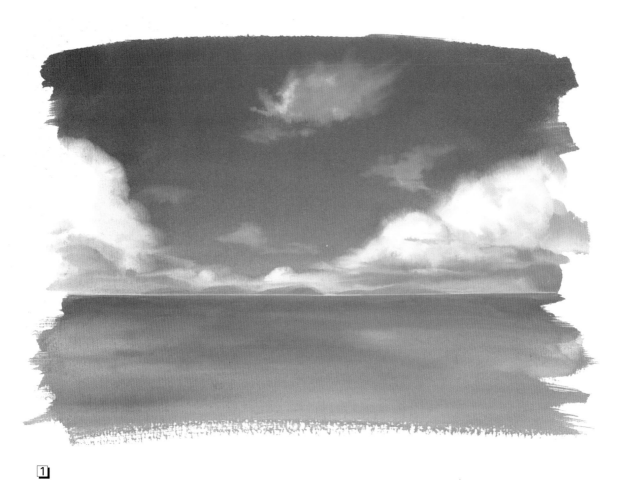

1

1. Mixing colors — Freely create colors

First, get rid of any coloring book-type perceptions you may have like painting the sky light blue, grass green and lemons yellow. In order to paint a space with a three-dimensional effect, you have to make full use of poster colors, create the optimum colors and express depth and the contrast between light and shade. A tree trunk will be brown, but the brown where light hits it and the brown where light does not hit it will be different. When you make colors, think about what colors are needed to express that.

Let's say you are going to paint the sea and sky. The sea is light blue. The sky is also light blue. How would you distinguish between the two? In picture 2, both the sea and sky were painted with light blue with no alterations. If you do it right, you can make the painting dynamic, as in this example. On the other hand, the sea and sky in picture 1 were painted with different shades of light blue. As a result, the painting is more dynamic and transitions are more pronounced.

2

Color chart

We have presented actual examples below of making colors darker through mixing for the purpose of adding contrast between light and shade to the color of an object.

Often both light and dark colors look like totally different colors when they are on the palette. For fear of this, you might make the mistake of mixing only slightly different shades of a color, however, on paper there will be no contrast between light and shade. You should be bold and make the contrast between shades sharp.

1. Original poster colors

Colors added

2. Colors are made slightly darker as a result of mixing.

3. Colors are made even darker as a result of mixing.

Contrast between light and shade was added
to a white cube using color No. 4 on the oppo-
site page. Dark green was added to the darker
parts.

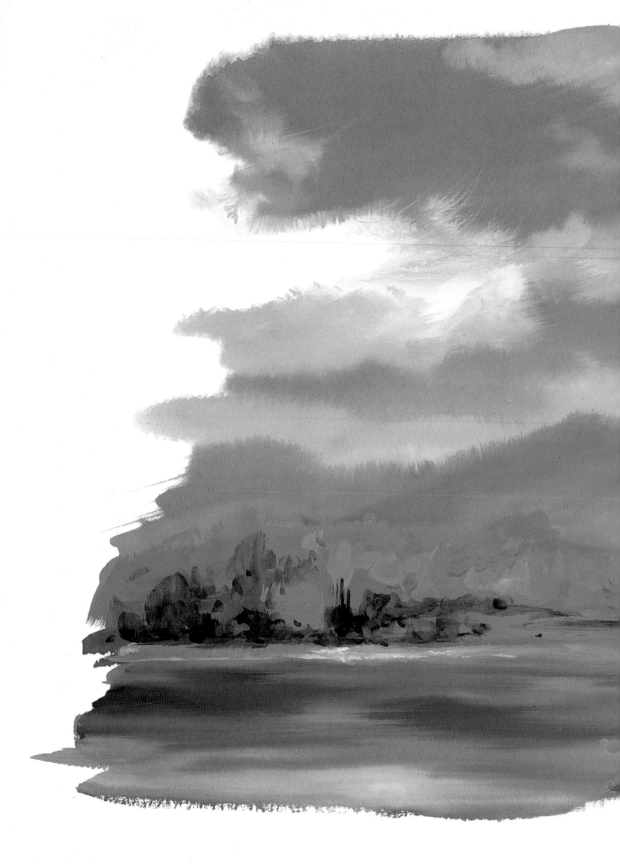

Place the background color in the thicket to make it look like you can see through it.

Create a three-dimensional effect by using different levels of color.

Make the backs of leaves in the fore-ground dark as well.

This color acts as a base and is almost invisible.

Make the light areas as light as possible.

Add blue to the brown croton tree for variation.

We isolated colors being used in different parts of the picture. Note how different the colors look when they are in the picture com-pared to when they are isolated.

◆ Flat application

This involves even application of a single color. You quickly paint right and left using a flat brush. Moderately dilute a poster color and repeatedly move the brush to the right and left, applying about half the width of the brush with each stroke.

◆ Groove painting

This is used when you want to draw a straight line. When you try to paint along a ruler to get a straight line, the paint will seep below the ruler and spread. Hold a glass rod (or a chopstick) together with the brush as if you were holding chopsticks. Place the glass rod in the groove of the ruler and draw a straight line without stopping. Note that the line will not be straight if the distance between the brush and the glass rod is not the same throughout the motion. Rubbing wax or a similar substance in the groove will make the glass rod slide more easily and will help prevent jagged lines.

How well you use brushes is important when drawing backgrounds given the nature of the pictures that are painted. You should at least master the typical and basic brush techniques.

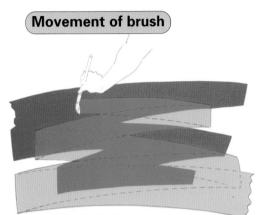

Color A: From top to bottom

Movement of brush

Color B: From bottom to top

◆ Gradation

This is a variation of flat application. You paint color A from the top and color B from the bottom in the same manner as flat application. Repeat several times so there are no brush marks.

◆ Blurring

This is used to make multiple colors hazy. Lightly apply color A and then fill in with color B. Move the brush back and forth a little where the two colors come together to make a secondary color on the paper.

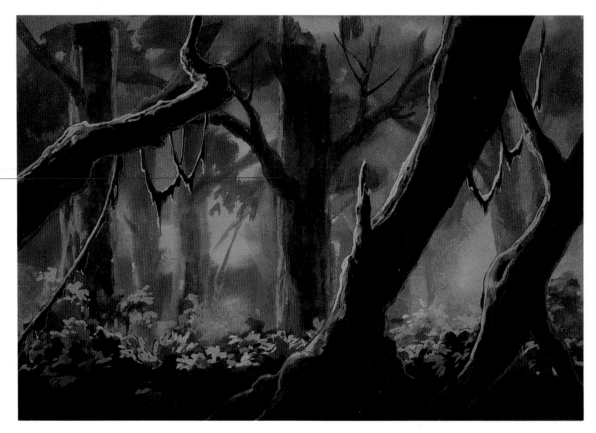

Trees in a forest

Drawing each individual tree in the distance would be a daunting task. Distinguish between trees that you want within viewing range and those that are far away while at the same time blurring trees that are far away using colors alone. Emphasize the contrast between light and shade on nearby trees because they are clearly visible.

Outer space

Outer space is essentially a pitch-black space and depth cannot be expressed without some objects, but it will look like outer space if you create light areas and dark areas and include your image of outer space. What you are doing is adding accent to a picture that potentially could just be a single color. Dot the picture with stars of varying sizes. Do not place the stars in a uniform pattern and make sure they are not too clumped together.

A background picture contains both areas that should be clearly shown and those that should not. Use clear, sharp contours and colors for things you want to show the most.

In general, distinguishing between objects in the middle and those that are extremely close and far away makes it easier to create a sense of depth.

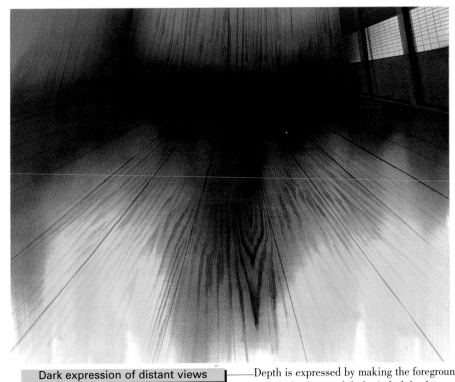

Dark expression of distant views —— Depth is expressed by making the foreground bright and the background dark. A dark background makes for an ominous picture.

Bright expression of distant views —— Depth is created by making the background bright. The effect is that of bright sunlight on a spring or summer day.

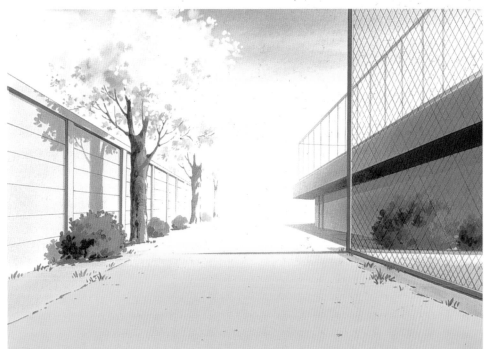

Let's try painting
Expression of Textures

Clouds and smoke

If you want to have moving smoke, you need to use cels, but smoke that has risen high in the sky is often used in backgrounds. Express the spread of smoke by erasing edges with an airbrush or by other means. Clouds are painted in the same manner, but the trick with clouds is to consider the direction of light and make the contrast between light and shade clear. Draw the edges of clouds with a brush so they are not too blurred. Make full use of gradation and blurring techniques.

Many flowers

Painting each individual flower is not practical, so think of flowers in terms of clumps.

Thickets

It is not practical to paint each individual leaf on a tree, so think of leaves in terms of clumps like you would with flowers. Think of their overall contour as you place colors in back and front. Do not glob the paint on. You should leave spaces so you can see a little bit of what is behind them. Use your brush carefully when creating spaces. Be sure not to spread the paint around excessively.

Close-up of one section

Floors

It is difficult to express depth because floors are flat. Add reflections to make floors look more realistic and create a sense of depth. Reflections will make floors look smooth. You can use this to distinguish between man-made surfaces and natural surfaces like the ground because natural surfaces are not smooth. The gap between floor tiles is black, but the edges of the tiles themselves are shiny so as to create a three-dimensional effect.

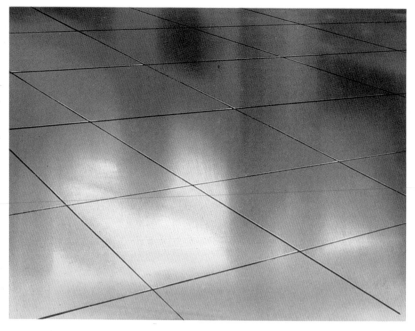

Man-made structures

Like floors, man-made structures are flat, smooth and mechanical. Always think "parallel" when using your brush. For objects with angles, change the movement of the brush in line with variations in the surface.

Backgrounds for transposition (background transposition)

For scenes where the background gradually changes from daytime to night, for instance, you make two backgrounds with the same form, one for daytime and one for night, and express the change by overlapping them. How light emerges, how it hits surfaces and even the textures of colors change.

Harmonization

Harmony is the presentation of an animation in the form of an illustration-type picture using cels and backgrounds and not in the normal cel animation fashion. A cel with contour lines is placed over a background picture. The contour is clearer than the background and the background offers subtle gradation superior to the cel. You can use this technique for characters to create a symbolic scene.

Contour lines transferred to a cel—Material 1

Picture drawn for background—Material 2

Completion

If the picture will not move, harmonization can be used for mechs and other objects to greatly improve their texture.

Before photographing

Let's try placing a cel over a background. By the way, more than one cel may be placed over a background. It is not uncommon to place two or three cels over a background.

The first cel put on the background is designated A, the next one B and so forth. You do not notice it on the TV screen, but cels for a character are sorted in this manner.

Background

Cel A Cel B

Background + Cel A

Background + Cel A + Cel B = **Completion**

This work is an original drawing done for this book.

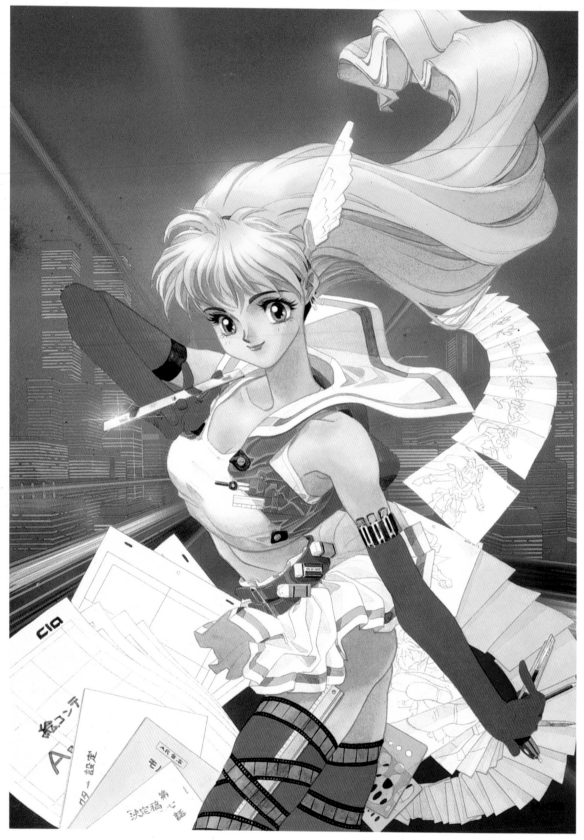

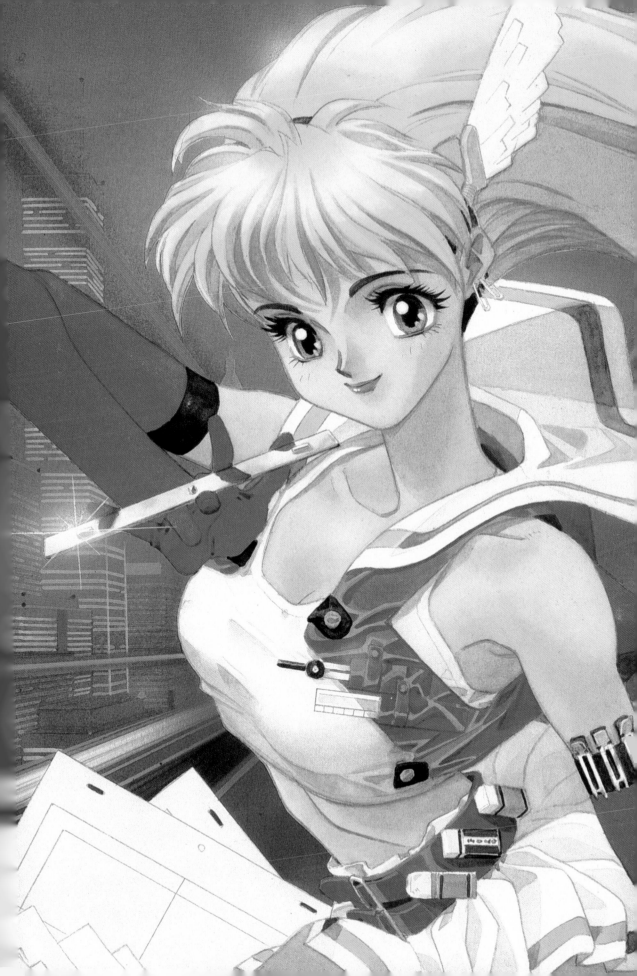

Filming (Photography)

The pictures will not move with the completed materials (cels and backgrounds) alone. The pictures come to life only after they have been photographed and are projected continuously.

Here we will present several special techniques used when photographing cels and backgrounds.

Fade-in (F.I.)
Fade-out (F.O.)

This is done by manipulating the camera. You start with an underexposed frame and slightly increase the exposure one frame at a time so that each picture gradually gets brighter. This technique allows you to have a scene appear gradually. This is called fade-in. Fade-out is just the opposite. A scene will gradually dissolve.

Fade-in

Fade-ou

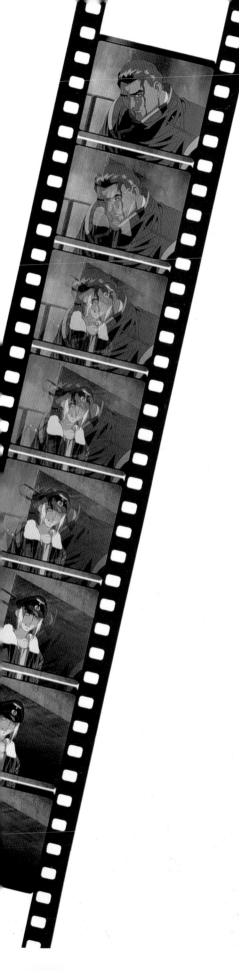

Overlap (O.L.)

First, you photograph a scene so that it fades out. Then you rewind the film and photograph the next scene so that it fades in. By doing this, the first scene dissolves while overlapping with the next scene (the next scene appears while overlapping with the preceding scene). This is called overlap.

Overlapping within the same cut is often referred to as O.L. Overlapping in the examples presented here is called overlap transition because a transition is made from one cut to the next using overlap.

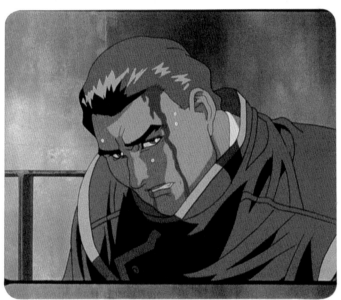

Double exposure (WXP)

The expression "double exposure" is often used when you alter only a part of a shot for some reason, such as when you want to make only characters look transparent.

In the example given here, a double exposure (often called "daburashi" in Japanese) is used to create the appearance of a semitransparent person reflected in a lens.

Material 1 alone

Material 2 alone

Completed shot

Incident light

Expression of light shining in from outside a shot. After photographing cels and background in the usual way, shine a light on some object located outside the frame that will reflect the light diffusely (there are a variety of things to choose from), and photograph the shot with the reflected light in the frame.

Material 1 alone

Material 2 alone

Completed shot

Transmitted light

When you want to make it look like a part of a shot is shining, rewind the film after photographing cels and background in the usual way and then photograph the same frame again with light alone.

Place on the table black paper cut out in the shape you want the light to be and photograph with the light source below. The shape will appear in the shot together with the normal cels and background.

Wavy glass

You often see expression of swaying water as if a shot was photographed under water or the shimmer of hot air caused by heat from flames. These effects are created using wavy glass during photography. An acrylic plate with bumpy waves is placed in front of the camera. You can create a swaying effect by sliding the wavy glass vertically and horizontally.

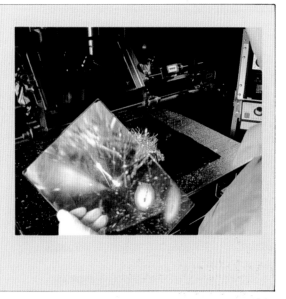

Flare-transmitted light **Example 1**

The area around the sparks from a gun is made to look hazy like light escaping.

Material 1 alone

Material 2 alone

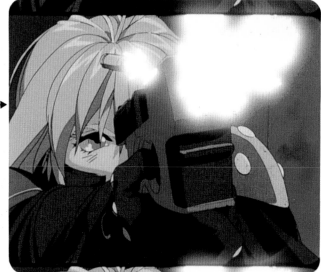

Completed shot

Material 1 alone

Material 1 alone

Material 2 alone

Material 2 alone

Flare-transmitted light is used to express electricity. A special cel called a "lith mask" is prepared to make the lines look like they are shining.

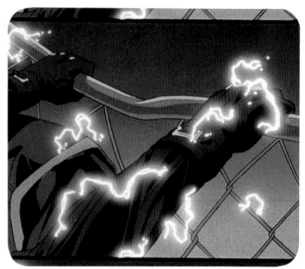

Completed shot

Pinhole light + cross filter

Holes were simply cut out of black paper and the light source was placed below the film. A "cross filter" was attached to the lens to make the light shine like a cross.

Completed shot

Chapter 3
Drawing Actions

From "Moldiver Resource Collection" published by AIC Club

Carefully Plan Actions

1. Make the situation clear

If you just draw aimlessly, your work will be nothing more than doodling. Drama is a product of a sequence of a variety of events, so you will need to draw various scenes. Think of the situation in which your character finds himself or herself in terms of the following.

1. Where is the character standing?
2. How far away is the character from other characters (if there are any)?
3. Are there any props?
4. What is in the background?
5. How big is the area?
6. What is the direction of the light?
7. Others

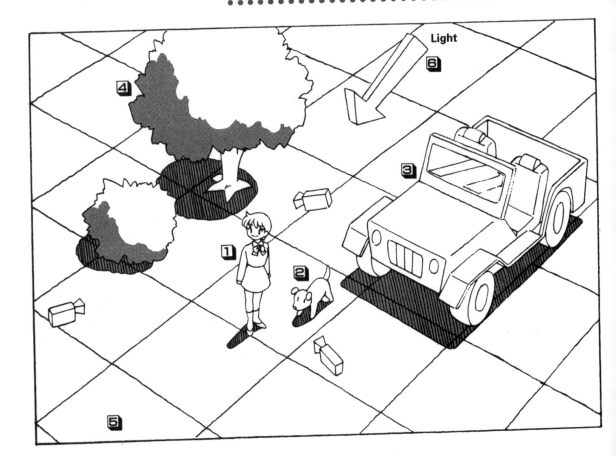

How will you present the situation?

◆ Will you present the character up close or from far away?

Bust shot

This is used when you want viewers to focus on the character. The facial expression of the character is accurately conveyed.

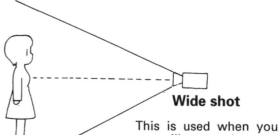

Wide shot

This is used when you want to illustrate the area around the character. The drawback is that it becomes difficult to see subtle facial expressions on the character.

◆ Will you show the character from below looking up or from above looking down?

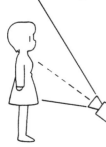

Looking up from below

This angle makes the character look important or full of hope.

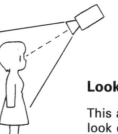

Looking down from above

This angle makes the character look dejected or in an unfavorable situation.

2. Trajectory
—Think about the action line

Think about how to move an object. Do not just think vaguely in terms of the position of the object changing. Have a clear idea of the path the object will follow. This path is called the "trajectory" or "action line." The quality of motion is dictated by this trajectory. Trajectory is present in all motions no matter how small. At this stage you carefully plan a motion.

Example:
Trajectory of an airplane in flight

⬜1 ⬜2 ⬜3

⬜1 ⬜2' ⬜3

Even if the starting position and the end position are the same, the motion will be completely different if the trajectory is different. As seen in ⬜1, ⬜2' and ⬜2", inserting a different picture between 1 and 3 results in different motions. The picture you insert in the middle will differ depending on the trajectory you come up with.

⬜1 ⬜2" ⬜3

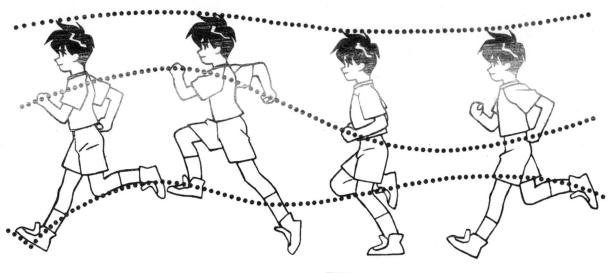

Running

When drawing pictures of someone running, you tend to focus on the motion of the hands and feet, but the body is also moving up and down at the same time. Think about both the trajectory of the body moving up and down and the motion of the hands and feet.

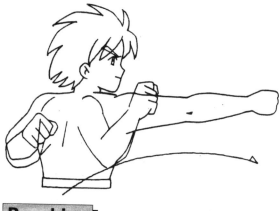

Punching

In a punching motion, the fist travels in a straight line, but the elbow does not. The freedom to choose what punching motion to use offers an animator the chance to show his or her skill.

Kicking

How the person being kicked falls down will differ depending on the motion of the leg doing the kicking. The kick should be a rotary motion that is natural given the structure of the human body.

3. Think about the laws of nature

A. Gravity and centrifugal force

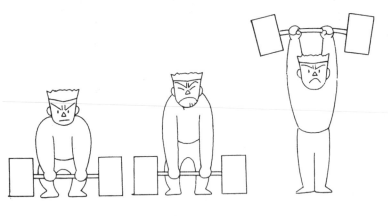

When picking up a heavy object, it will not look heavy if it is picked up with ease. You need to draw a picture in a way that makes the object look heavy. Create this effect by drawing a picture in which the weight of the object looks like it is being pulled straight down. The motion is adjusted by inserting this picture in the middle.

Weight is also exerted on a person who is simply standing around. A character that appears to be floating in a state of weightlessness will not look realistic. Use the turns and twists of the body to make it look like the center of gravity is over the feet of a character.

Good

Not good

Not good

1

2

Good 2´

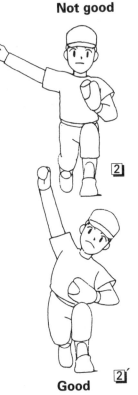

3

When drawing a character in motion, do not draw a picture that makes it look like the character is frozen (picture 2). The picture must look like the character is in the middle of a motion (picture 2´), as if the picture was a frame that was removed from a film of a continuous motion. You have to be able to take one look at the picture and almost feel the centrifugal force and the opposing force pulling it.

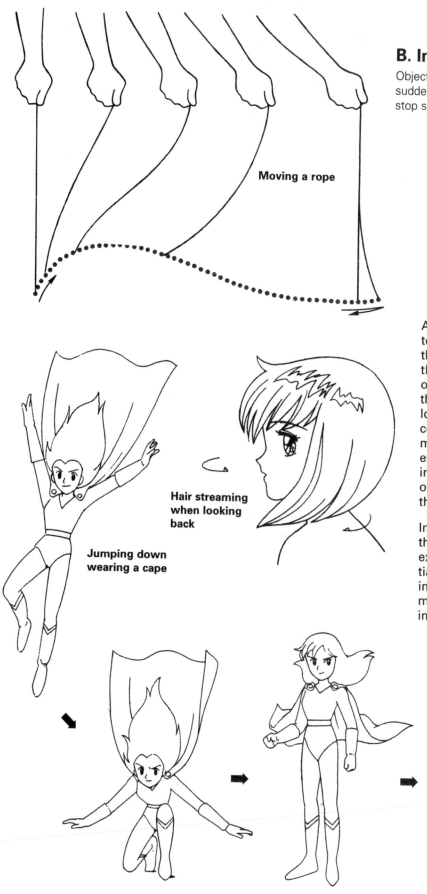

B. Inertia

Objects standing still do not move suddenly and moving objects do not stop suddenly. This is called inertia.

Moving a rope

Hair streaming when looking back

Jumping down wearing a cape

All objects, not just characters, can be divided into those that move and those that are moved. Inertia often appears in objects that are moved and it follows objects that move. You could say that objects that move pull it. You can express motion by staggering the timing of movement of objects that move and those that are moved.

Inertia is always present in the natural world to some extent. The amount of inertia will vary greatly depending on the speed of a movement. Note this when drawing in-betweens.

4. Exaggeration (deformation)

Like a still picture, exaggeration is also used in moving pictures. Even if the starting position and the end position are fixed, use of exaggeration in between will give the motion a slightly different flavor.

Here are some examples of "squishing" and "stretching." The normal action line has been ignored intentionally and the shape of the character has been changed to create an exaggerated effect.

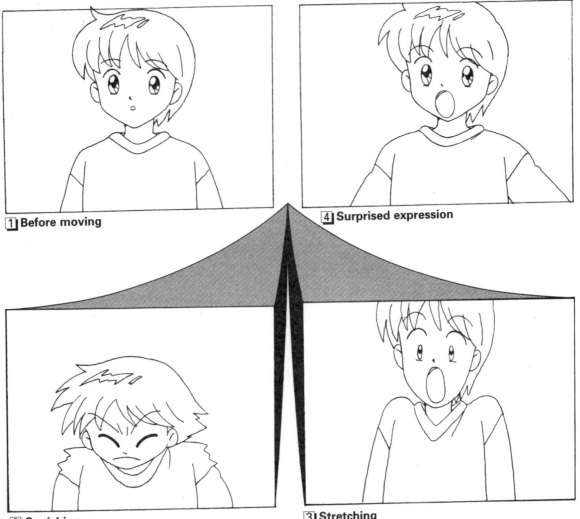

1 **Before moving**

4 **Surprised expression**

2 **Squishing**

3 **Stretching**

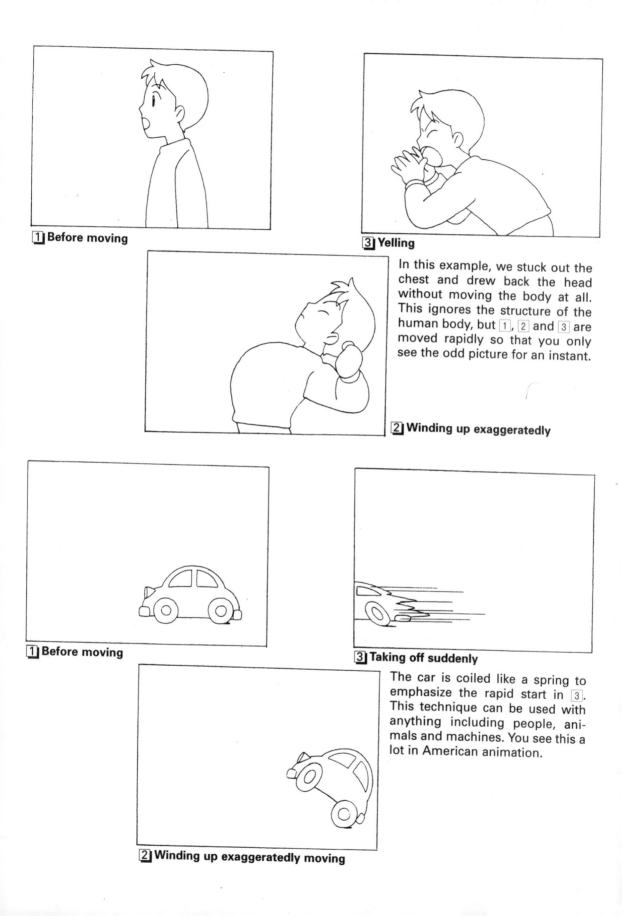

1 Before moving

3 Yelling

In this example, we stuck out the chest and drew back the head without moving the body at all. This ignores the structure of the human body, but 1, 2 and 3 are moved rapidly so that you only see the odd picture for an instant.

2 Winding up exaggeratedly

1 Before moving

3 Taking off suddenly

The car is coiled like a spring to emphasize the rapid start in 3. This technique can be used with anything including people, animals and machines. You see this a lot in American animation.

2 Winding up exaggeratedly moving

5. Move objects using "ghost" effects

You have probably taken a photograph that has turned out to be blurred. The color of people and background in a burred photograph appears to flow. Even if a photograph is not blurred, the subject of your photograph leaves a trailing image if it moves quickly. A "ghost" effect is used to represent this trailing image in order to create a sense of speed.

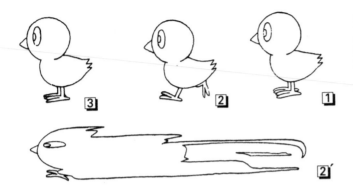

If you try to make it look like the chick is moving quickly from 1 to 3, pictures 1, 2 and 3 will look like separate pictures if you insert just picture 2 in between and it will not appear to move smoothly. If you insert 2', however, the ghost effect will make it look like the chick is moving quickly from 1 to 3.

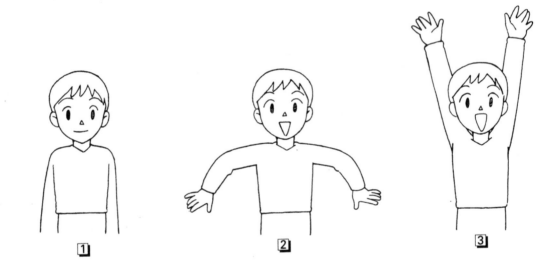

By the same principle, when you raise the hands from 1 to 3 the arms will look out of synch if you insert 2. The motion will be rapid and smooth if you insert 2'.

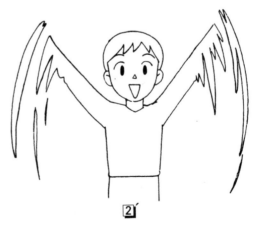

In this example, squishing was inserted as the character was moved from ①to ③, but the action is not quite exaggerated enough. The action will be exaggerated if you use a "ghost" effect to make it look like the character is flapping her arms.

Let's say you want to instantly move a character from the position in ① to the position in ③. You cannot draw an intermediate character that will fit in between ① and ③. Here we had the character jump from the position in ① to the position in ③. A ghost was drawn over the trajectory and inserted in the middle. Ghosts enable you to move objects at speeds that are not physically possible.

Note that "ghost" effects that exaggerate speed are mainly used in comical animations. They are totally unsuitable in almost all serious works.

Action Points

First, think about the trajectory and how an action will unfold. It is not wise, however, to draw each little movement in order from the beginning. It is more efficient to draw the pictures with the main poses first.

These main poses are roughly picked out from the actions of a character. You do not, however, just randomly pick them out. You must consider various elements.

1. Start and end of a motion

Here we are talking about from where to where an object will move. The first two pictures you need to draw are the start and end of a motion. Then you can fill in the gap between them with the action you desire.

Picture 1 is an upright pole. Picture 7 is the pole on the ground. Pictures 2, 3, 4, 5 and 6 are the pole falling. Picture 6 is the pole bouncing after hitting the ground.

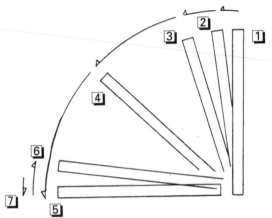

1 Start

2 End

A dozing girl tries to fight off her sleepiness. She not only opens her eyes but also raises her face.

1 Start

2 End

A boy looking to the side turns his head forward.

From standing position to sitting position. The gap between these positions is filled with pictures that differ slightly to create an animation of a person sitting down.

1 Start

2

3 End

✪ "Start and end of a motion" and "start and end of a cut"

The "start and end of a motion" are pictures 1 and 8, but let's say you will only show the audience pictures 4 to 8. In this case, the start of the cut is picture 4 and the end of the cut is picture 8, so pictures 1 to 3 are not necessary. An animated film is made up of individual cuts that have been joined together. It is not uncommon to leave out the start or end of a motion.

Be sure to number the pictures you have drawn for a motion.

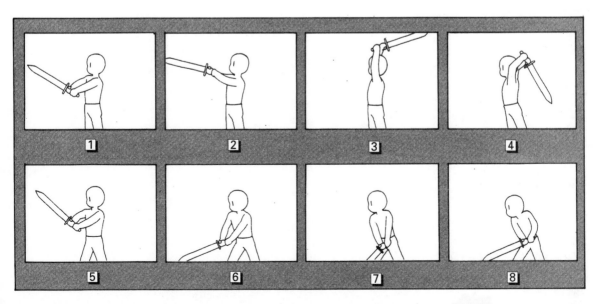

1 2 3 4

5 6 7 8

2. Points where power is exerted during a motion

Like gravity and centrifugal force, you have to draw a realistic picture at points where power is exerted. The picture will differ greatly depending on whether you include this pose or exclude it from a motion. The picture where the most power is exerted is an important part of a motion. Let's try drawing the point where the most power is exerted in a motion.

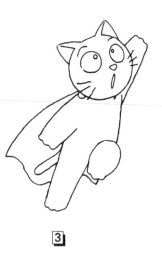

1

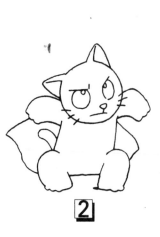

2

3

Here we have a cat standing 1 and flying 3. The picture with the cat flying makes it look like the cat is jumping, but these two pictures alone are not enough to make the cat fly. Filling the gap between these pictures with pictures that change bit by bit will only make the cat "float." Picture 2 is necessary to make the cat fly.

2

1

3

Picture 2 is required to move the character from picture 1 to picture 3.

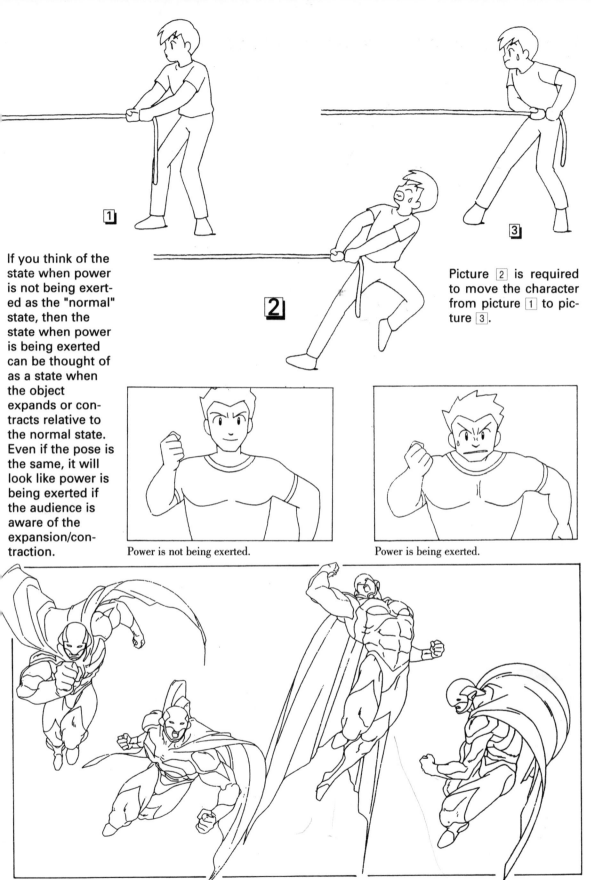

If you think of the state when power is not being exerted as the "normal" state, then the state when power is being exerted can be thought of as a state when the object expands or contracts relative to the normal state. Even if the pose is the same, it will look like power is being exerted if the audience is aware of the expansion/contraction.

Picture ☐2 is required to move the character from picture ☐1 to picture ☐3.

Power is not being exerted.

Power is being exerted.

From "Moldiver Resource Collection" published by AIC Club

3. Make motions fluid

The human body is made up of many parts connected by joints. It would be strange if the movement of a character were to be stiff like a doll being manipulated.

A

1

2'

2

3

B

1

2

2'

3

Picture 2 in both **A** and **B** is unacceptable if you want to draw a character turning around. Try drawing it so that it looks like the parts doing the twisting pull the other parts. The face should move ahead of the shoulders and arms, like in picture 2'.

When a part of the body pulls an object or another part of the body, it is called "follow through". In cartoons from countries other than Japan, you sometimes see motion where one object or part of the body appears to be stuck to something, this is an exaggeration of follow through.

When making a follow through, the farther an object or part of the body is from the part that is pulling it, the more you should curve it towards its original position.

C

Picture ② is not natural if you are about to grab something. Picture ②' is necessary. It looks like the character is about to grab the apple.

- -

D

①

②

②'

People do not get up like the character in picture ②. The legs and lower back of the character in picture ②' look natural.

③

4. How to make motions powerful

The same motion will be viewed differently by the audience depending on how it appears on the screen.

When you want to create a powerful image, try making the motion so big that the picture spills outside the frame. If you try to squeeze the entire picture into the frame, the picture and the motion will look cramped at the expense of power. You can rapidly close the distance between the character and the audience by moving the vantage point (camera) closer to the character. The motion of a character that is close to you is naturally more powerful.

A

Here are some specific examples. Add a picture where an object on the screen looks like it could almost come into contact with the audience. For instance, you could have the hand of a character pass several centimeters in front of the faces in the audience. For such a picture, all you have to do is follow the rule of making the parts that are near bigger and the parts that are far away smaller.

B The exaggeration mentioned earlier was incorporated into these pictures. Picture 1 is a normal surprised look. Picture 2 has more impact. Picture 3 is an "It's the end of the world" expression. Picture 3 is sure to be a hit with the audience.

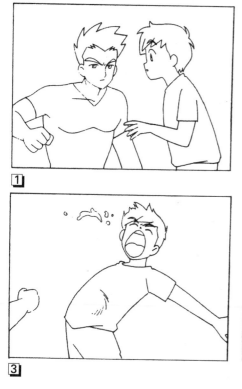

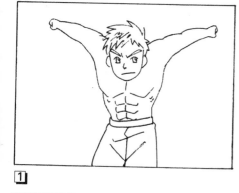

C This example also incorporates exaggeration. We added a manga-style impact that should not be visible through the character's back.

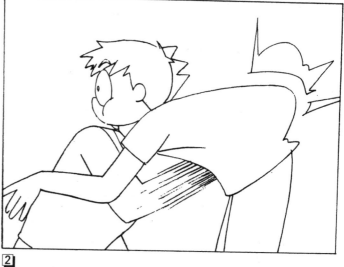

D We used a "ghost" effect to create a sense of speed and we tried to create a visual effect where the audience comes close to being kicked.

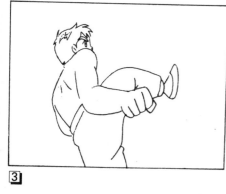

5. Main poses within motions

Unlike the pictures designed to make a motion consistent with the dispensation of nature and those designed for dramatic effect shown in the preceding sections, here we will present poses that must be prepared in order to make pictures move.

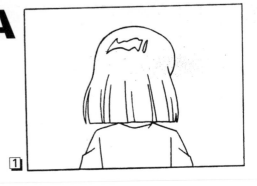

1

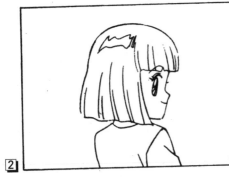

2

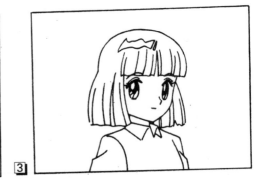

3

When having a character turn around, just showing the back view (picture 1) and the front view (picture 3) will not give us any idea how the face comes into view. You need a picture in between that shows this. Without picture 2, it could possibly look like the character turned around from the left. Furthermore, the character could also turn around with the neck slightly tilted for dramatic effect. It is important to depict, in the form of specific pictures, the action you have in your head.

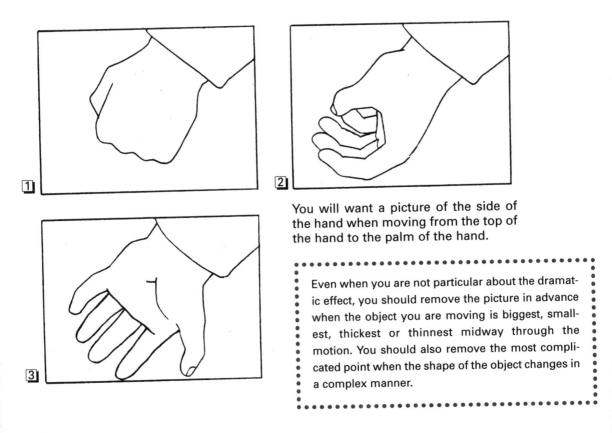

1

2

3

You will want a picture of the side of the hand when moving from the top of the hand to the palm of the hand.

Even when you are not particular about the dramatic effect, you should remove the picture in advance when the object you are moving is biggest, smallest, thickest or thinnest midway through the motion. You should also remove the most complicated point when the shape of the object changes in a complex manner.

C

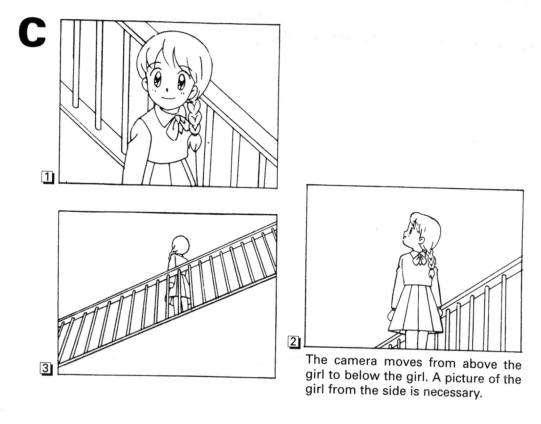

The camera moves from above the girl to below the girl. A picture of the girl from the side is necessary.

D

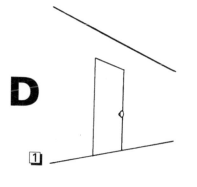

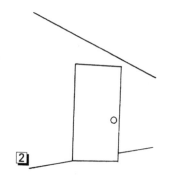

The precise size and shape of the door cannot be determined with just pictures 1 and 3. Picture 2 makes it clear what kind of door it is.

6. Analyze motion when drawing

Use of the word analysis may be going a little too far. What we want to say is that you should think of motion in terms of segments.

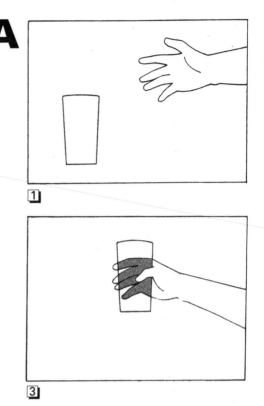

A

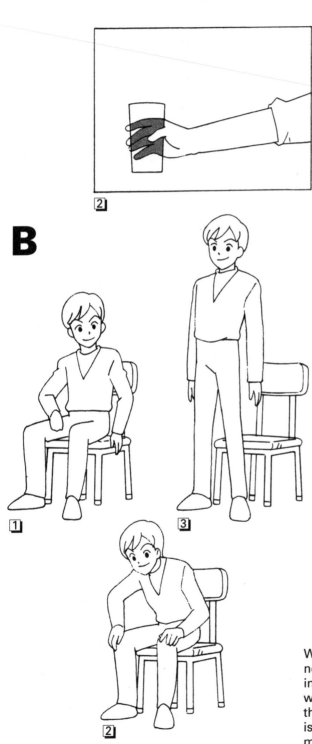

B

A "grabbing" motion involves several movements: 1. Raising the arm, 2. Twisting the arm to facilitate grabbing while extending the arm, 3. Opening the hand, 4. Touching the object, 5. Closing the hand and 6. Lifting the object up. Performing each of these actions separately would look robotic, but when performed by a human the motion is smooth.

The motion of grabbing a glass requires at least three types of picture: 1, 2 and 3. Almost all the actions we subconsciously perform every day are made up of a combination of subtle movements. Gradually think about how objects are moving before drawing.

When standing up from a chair, a person does not float from the position in picture 1 to that in picture 3. A person has to place their weight on their legs (picture 2). This is also the pose where power is exerted. This motion is called "preliminary movement" or "prior movement."

C

1

2

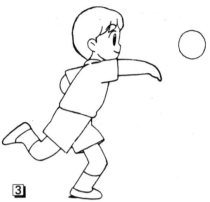

3

When throwing a ball, you "prepare" for the throw by drawing the ball back to build up power.

D

1

2

3

A person who is running cannot stop on a dime. A movement that shows the person reducing speed is inserted.

Techniques for making motions three-dimensional

1. Tricks for thinking of pictures three-dimensionally

Pictures are drawn using contour lines, but shapes are not represented by contour lines alone. Even a slight change in the angle at which an object is viewed will shift the contour of the object to a different location.

Since you draw contour lines to match the angle at which an object is being viewed, a slight change in the angle will force you to redraw the three-dimensional object on a two-dimensional surface as a different picture, even if it is the same object.

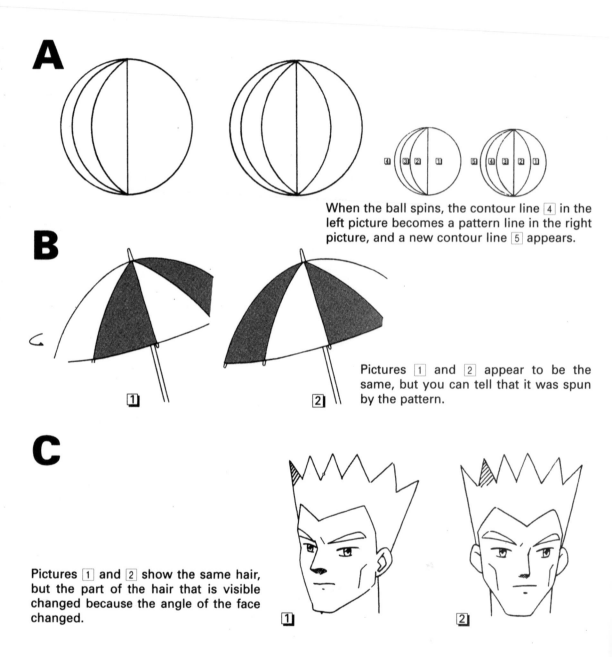

A

When the ball spins, the contour line 4 in the left picture becomes a pattern line in the right picture, and a new contour line 5 appears.

B

Pictures 1 and 2 appear to be the same, but you can tell that it was spun by the pattern.

C

Pictures 1 and 2 show the same hair, but the part of the hair that is visible changed because the angle of the face changed.

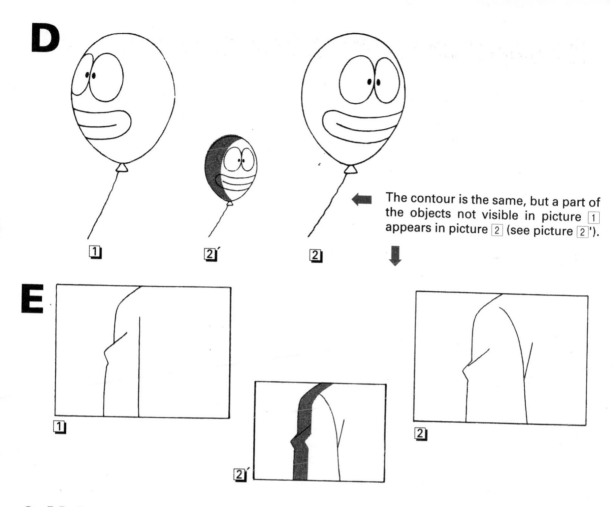

D

The contour is the same, but a part of the objects not visible in picture ①appears in picture ② (see picture ②′).

E

2. Make sure that characters do not "lose their shape"

We say that characters "loses their shape" when the same character looks different in different pictures. Be careful because this phenomenon can occur when drawing machines and small objects as well.

A

Good

Not good

This dog has a normal build. The length of its body will not shrink when viewed from the side.

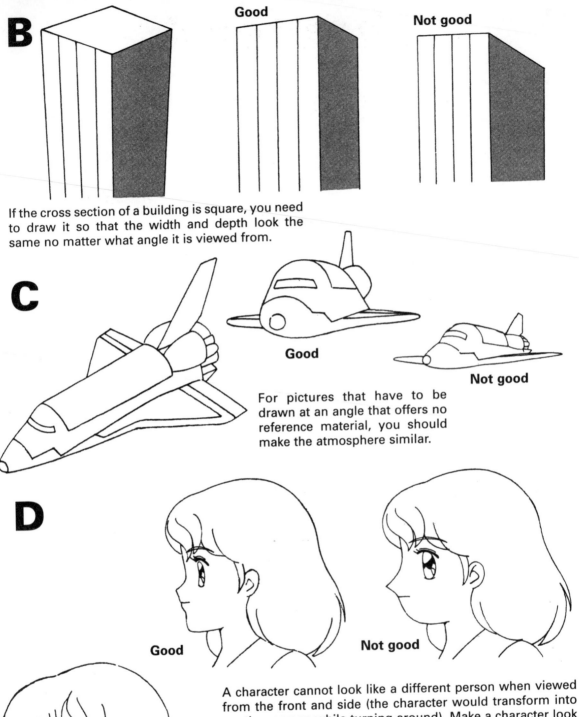

B

Good

Not good

If the cross section of a building is square, you need to draw it so that the width and depth look the same no matter what angle it is viewed from.

C

Good

Not good

For pictures that have to be drawn at an angle that offers no reference material, you should make the atmosphere similar.

D

Good

Not good

A character cannot look like a different person when viewed from the front and side (the character would transform into another person while turning around). Make a character look the same even if the angle from which it is viewed changes.

Pay attention to the following in order to make a character look the same.
• Accurately grasp the shape of parts
• Accurately grasp the balance between parts
• Grasp the atmosphere
Grasping the atmosphere is particularly difficult, because much depends on the latent ability of the artist, but the trick to making a character look the same is to give concrete form to the visual image of a character. Capturing the atmosphere is indispensable.

Chapter 4
Tips for Improving the Fun Factor of Animations

From "Moldiver Resource Collection" published by AIC Club

Making Animations is the Same as Shooting a Film

Characters in an animation are actors and animators are the cameramen who film the actors. You should draw pictures as if you were looking through a camera. Always be conscious of the "camera."

1. Think about the visual field, visual angle and visual cone

Pictures will be round if you draw the entire expanse of space visible at one time. They will be round because both eyes and camera lenses are round. This range of sight is called the visual field. The screen is one part of the range of sight cut out in the shape of a frame. In a film, the pictures within this frame become the visual field of the audience. A cone whose base is the visual field and whose vertex is at the eye (camera) is called the visual cone. The angle of the vertex of the cone is called the visual angle. An object is within the visual field if it is within the visual angle.

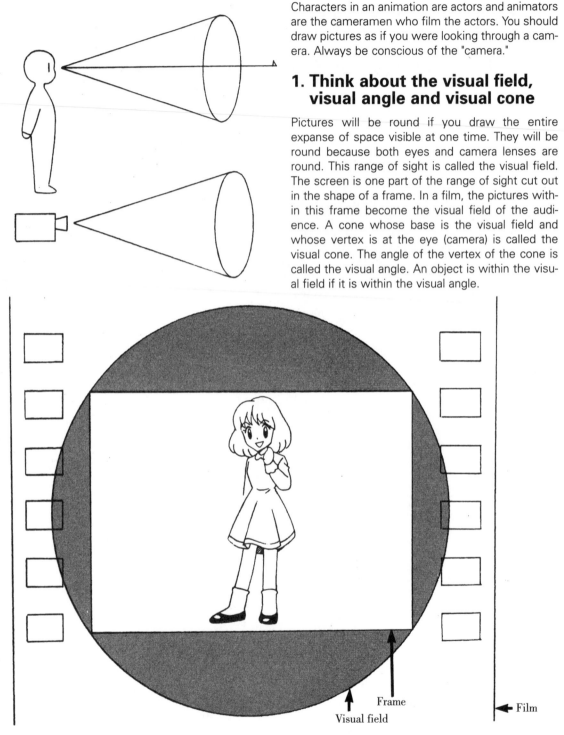

Frame

Film

Visual field

The part cut out of the visual field in the shape of a frame is what fits on the film.

2. Think about where the horizon is

The ground will generally be completely flat (the earth is round, but it is very big). Think about where the horizon is in the picture. If the eyes are parallel with the ground, the horizon will be in the center of the screen. If not, think of this as a yardstick. The relationship between a character and the horizon will differ depending on the height of the eyes (camera height) relative to the character. A horizon that is above or below the center of the screen indicates that the eyes are not parallel with the ground.

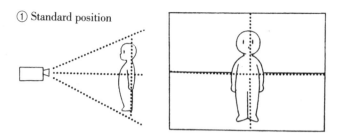

① Standard position

Telephoto and wide-angle lenses

You can have a close-up of a character by using a telephoto lens and you can make a character smaller by using a wide-angle lens, without changing the distance between the character and the camera. The size of the character within the frame looks different because the telephoto lens makes the visual field narrower and the wide-angle lens makes it wider.

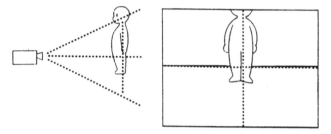

② Lowering the camera (low position)

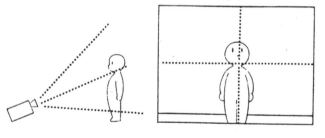

②' Looking up from low camera position (low angle)

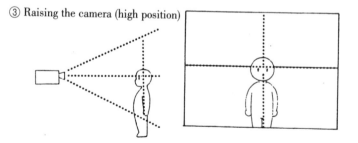

③ Raising the camera (high position)

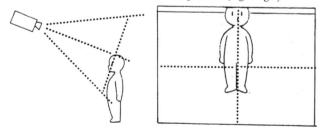

③' Looking down from high camera position (high angle)

3. Perspective lines are curved

The straighter an object is, the more curved it will look. This statement may surprise you, but it is true. An object that is physically straight always has parts that are near and far from the eyes (camera). A straight object will look almost completely straight when viewed from the front, but the parts of a picture not at the center of the visual field will be viewed at an angle from the eyes (camera), so the distance will be different relative to the front view. You will need to deftly distinguish between these differences in angle and distance when drawing.

Conceptual drawing of spatial distortion as seen through a lens

Appears to be at an angle

Appears to be directly below

Completely flat ground

Frame a Frame b Frame c

Let's say we are looking at a straight wall. When the wall is viewed from directly in front of it (frame a), all the lines appear to be straight, parallel lines. When you move your eyes to the right, however, you are viewing the wall diagonally (frame b), and the wall lines are no longer parallel.

Since the angle at which the wall is viewed becomes sharper the farther in the back you go, the portion of the wall (frame c) between the edge of the wall and the front can only be drawn with wall lines that are curved.

We drew a building based on the preceding concept. When you try to combine in one picture the part of the building you look up at, the part you look down at and the part in between, with their different perspectives, you end up with a mysterious building made up of all curved lines. If you show this strange picture only within their respective frames, it will not look that out of place. This type of picture is often drawn intentionally when making an animation.

4. Exaggeration of perspective

A close-up of the same character created using a telephoto lens and that created using a wide-angle lens will be different.

Since the wide-angle lens has a wider visual field, you have to be very close to the character to get a close-up. Such a shot will be powerful because the character is near the audience. In order to let the audience know that it is near the character, you have to draw a picture that gives the impression that it was shot with a wide-angle lens. Exaggeration of perspective is an effective means of creating this difference.

Wide-angle lens

Telephoto lens

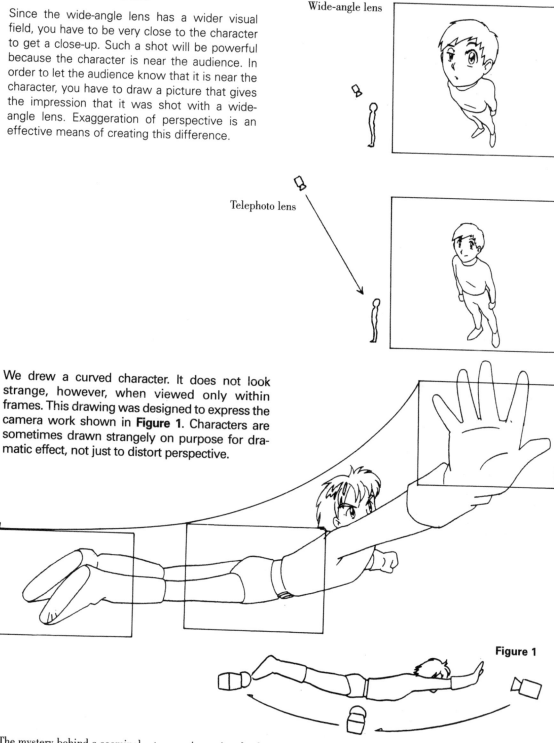

We drew a curved character. It does not look strange, however, when viewed only within frames. This drawing was designed to express the camera work shown in **Figure 1**. Characters are sometimes drawn strangely on purpose for dramatic effect, not just to distort perspective.

Figure 1

The mystery behind a seemingly strange picture is solved when you are aware of the presence of the camera.

Let's say that a camera is placed in a certain position and a character walks in front of it in a straight line. The character passes in front of the camera. The character is viewed from the side the instant it goes by the camera (b), but when it approaches (a) and moves away from (c) the camera, it is not viewed from the side. This is because the angle of the character as seen from the camera is different in each frame.

Conceptual drawing of walking action

a

b

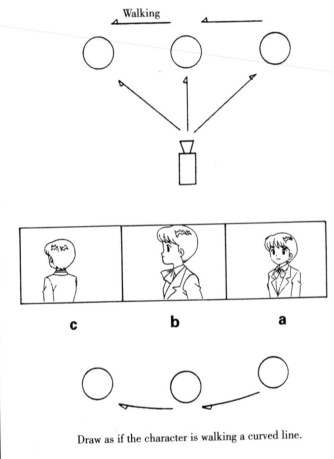

c b a

Draw as if the character is walking a curved line.

c

112

We drew two standing characters to look at the difference between them. When the characters are viewed with the same lens, both characters pretty much face the camera when they are shot from a distance, but they look like they are turning away from each other when shot close up. Even if the way the characters are standing does not change, a change in camera position not only changes the size of the characters but also affects other changes. The direction the characters are facing in each picture is the direction of spatial distortion.

Shot from a distance

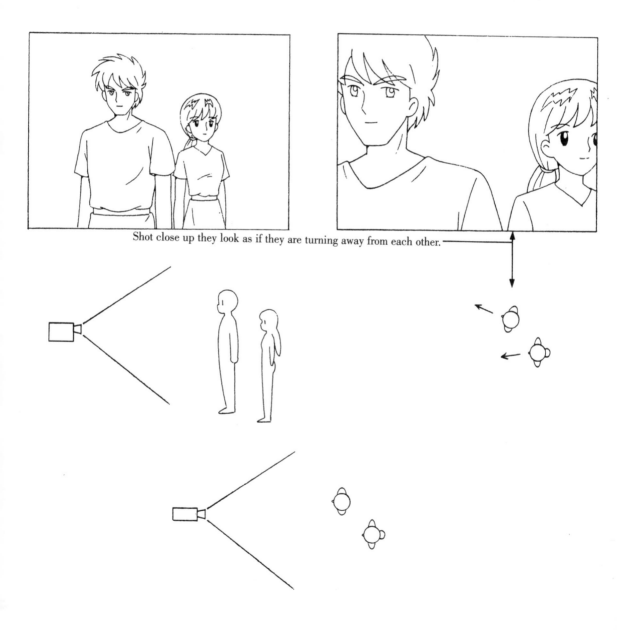

Shot close up they look as if they are turning away from each other.

5. Depth

When you watch Formula 1 racing on TV, the cars look like they are crawling along when you see them from far away, but they appear to gradually pick up speed as they get closer. Even if the cars are moving at the same speed, the distance they travel and the "change in size" increase with increasing speed as the cars get closer, and they move extremely fast very close up.

There is a large difference in the amount of change between the cars in the distance and those nearby even if physically they are moving the same distance and at the same speed.

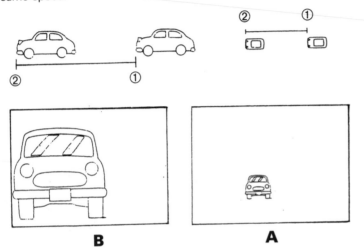

Movement in the depth direction is expressed by changing the size of an object. If the movement from ① to ② is viewed from the front, then A and B are equivalent to ① and ②, respectively.

Speed is expressed in terms of percentage change. If the speed of the movement is the same, (a) is correct. The foreground is slow in (b).

The pictures needed for the same action will differ depending on whether the length of time required for the action is long or short. Furthermore, the image of the screen itself will differ. Is the action slow, quick or a combination of the two? If it is a combination of the two, think about how the pace is varied.

(A)

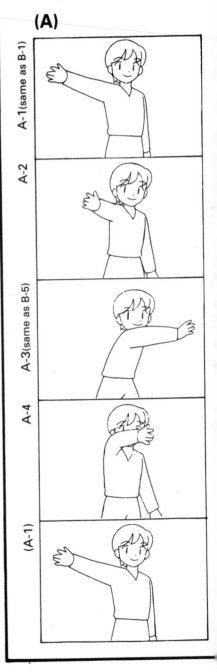

A-1(same as B-1)

A-2

A-3(same as B-5)

A-4

(A-1)

Timing of Actions

1. Speed of actions

A-1 and B-1 are the same pictures, as are A-3 and B-5. Using these pictures, we created an action with one cycle consisting of four pictures (A) and an action with one cycle consisting of eight pictures (B).

B, which has more pictures, naturally appears to move slower, but did you notice that this is not just because there are more pictures? Both A-2 and B-3 are in the middle of A-1 and A-3 and B-1 and B-5, respectively, but they are slightly different. A-4 and B-7 are also different. This occurred because the animator determined, based on experience and intuition, that these pictures were necessary if the character was to move at a certain speed. As you can see, it is important to imagine the speed of an action in your head and draw the pictures necessary for the motion.

(B)

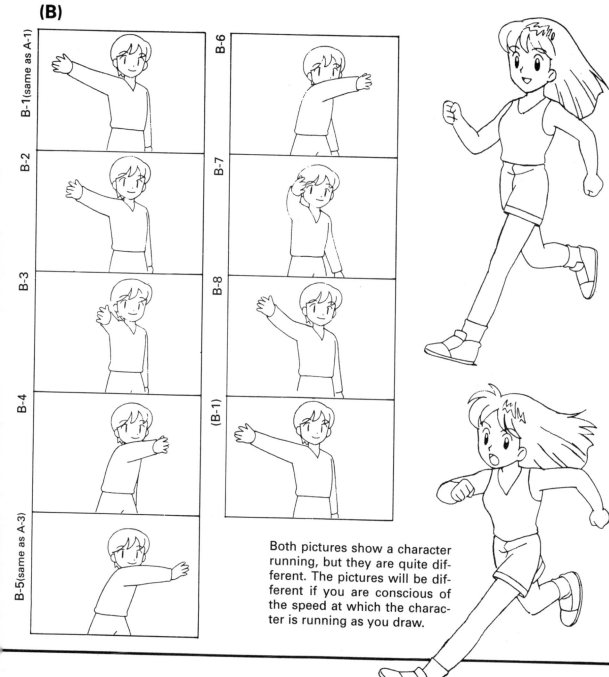

Both pictures show a character running, but they are quite different. The pictures will be different if you are conscious of the speed at which the character is running as you draw.

2. Three frames, two frames and one frame

Movie film runs at twenty-four frames per second. Television and other video signals use 30 frames per second. That is equivalent to 24 or 30 flip-it cartoon pictures in the course of one second. In the case of most Japanese animations, 24 frames per second are used and the same picture is used for three consecutive frames, so you only need eight pictures per second. This is done because the pace of motion is altered by manipulating the length of time each picture is shown, making use of the fact that an object will appear to move with as few as eight pictures. The same picture is usually shown for three consecutive frames (filming on threes) and then only two frames in a row (filming on twos) or one frame (full animation) for special scenes. The motion will be faster only where one or two frames are used (machine traced or hand traced).

Even if the motion is the same, the pictures will differ depending on whether the pictures in between are filmed on threes or whether it will be full animation requiring three pictures. This is the same as each picture being different depending on how many pictures will be used in between that we mentioned before.

The quality of motion will depend on how many pictures are used, how many frames each picture is filmed and what kinds of pictures are used.

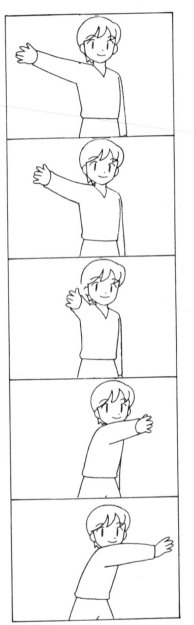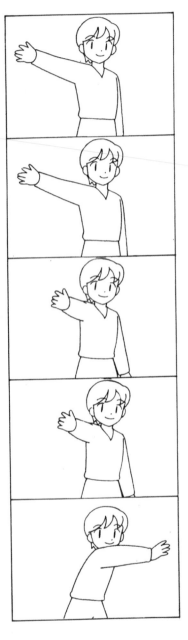

116

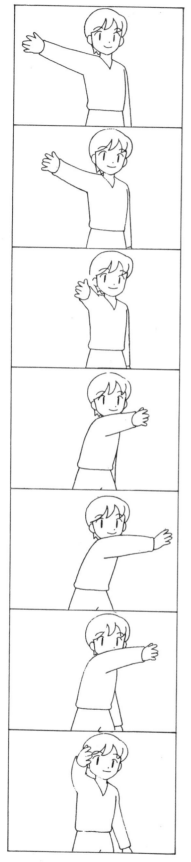

One frame (full animation)

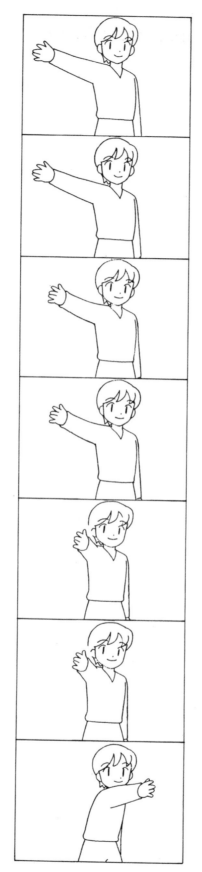

Two frames

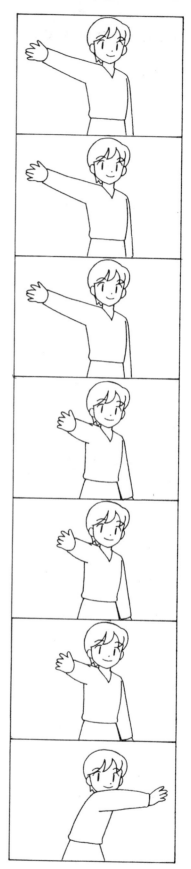

Three frames

117

3. Number of in-betweens

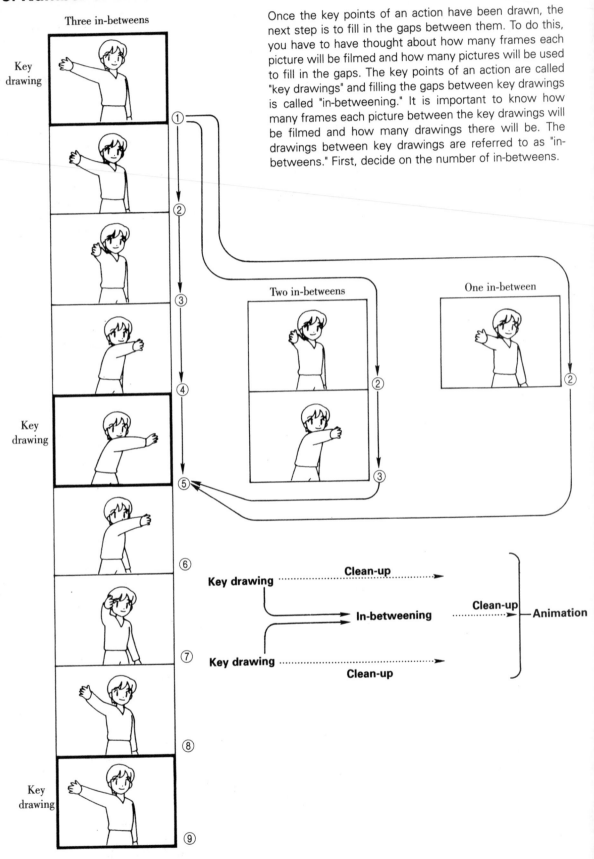

Once the key points of an action have been drawn, the next step is to fill in the gaps between them. To do this, you have to have thought about how many frames each picture will be filmed and how many pictures will be used to fill in the gaps. The key points of an action are called "key drawings" and filling the gaps between key drawings is called "in-betweening." It is important to know how many frames each picture between the key drawings will be filmed and how many drawings there will be. The drawings between key drawings are referred to as "in-betweens." First, decide on the number of in-betweens.

Time sheet

How many in-betweens will there be and how many frames will each be filmed? It can get confusing trying to keep track of this in your head, so a table is used. This table is called a time sheet in the domain of animation. The time sheet has places to write actors' lines and camera work in addition to information about moving pictures (see page 124 for an illustration of a complete time sheet and further details).

A time sheet could be thought of as the blueprint for a single cut. Animations are filmed on the basis of these time sheets.

Every animator must have a stopwatch. An animator moves a character in his or her head and times the movement.

If there are exactly two seconds between two key drawings, you will need 15 pictures if each is used for three consecutive frames and 23 pictures if each is used for two consecutive frames.

By numbering pictures consecutively on a time sheet, you can see at a glance what the total number of animation drawings will be when a certain number of in-betweens are used. The left columns are for indicating key drawings and the number of in-betweens. The right columns are the numbers of animated drawings that need to be completed.

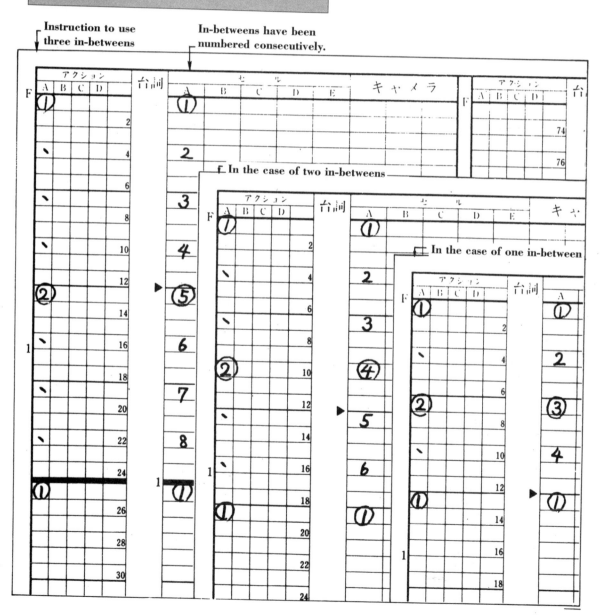

Instruction to use three in-betweens

In-betweens have been numbered consecutively.

In the case of two in-betweens

In the case of one in-between

4. In-betweening—Filling the gaps between key drawings

Now then, let's do some in-betweening. Confirm the number of pictures between two key drawings and then go over again in your head the motion you have planned. The thing that looks like fish bones in the illustration is used to designate how many pic-tures there will be between two key drawings and to what extent the in-betweens should change. The longer the distance between the numbers is, the greater the movement or change will be.

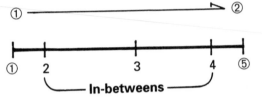

Key drawing number

Animation drawing number = cel number

In-betweens

Action

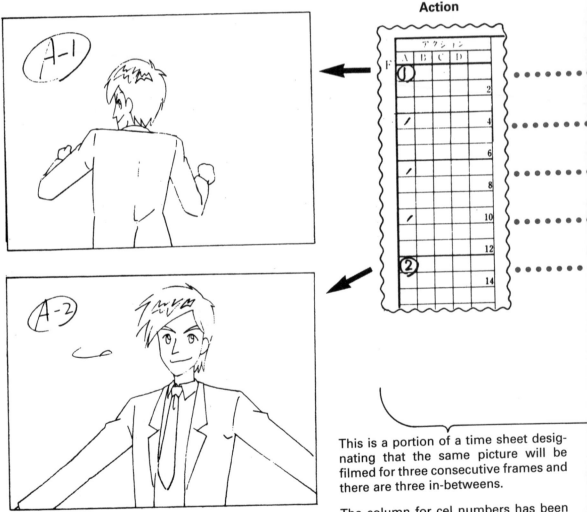

This is a portion of a time sheet designating that the same picture will be filmed for three consecutive frames and there are three in-betweens.

The column for cel numbers has been filled in based on this. Assign animation drawing consecutive numbers to the animation drawings.

Sometimes no in-betweens are needed between key drawings. In-betweens can also be placed at almost equal intervals. These in-betweens will not be used if you are aiming for a realistic scene.

A-2

A-3

A-4

Cel

5. Peg bar alignment

Drawing key drawings is a very difficult task, but drawing in-betweens is no less so. After all, you have to draw characters that look just like those in the key drawings many times and from different angles and in different sizes.

Peg bar alignment is a method used to help make in-betweening a little faster and more accurate. Peg bar alignment is a method and not a technique, so anybody can do it once they know how.

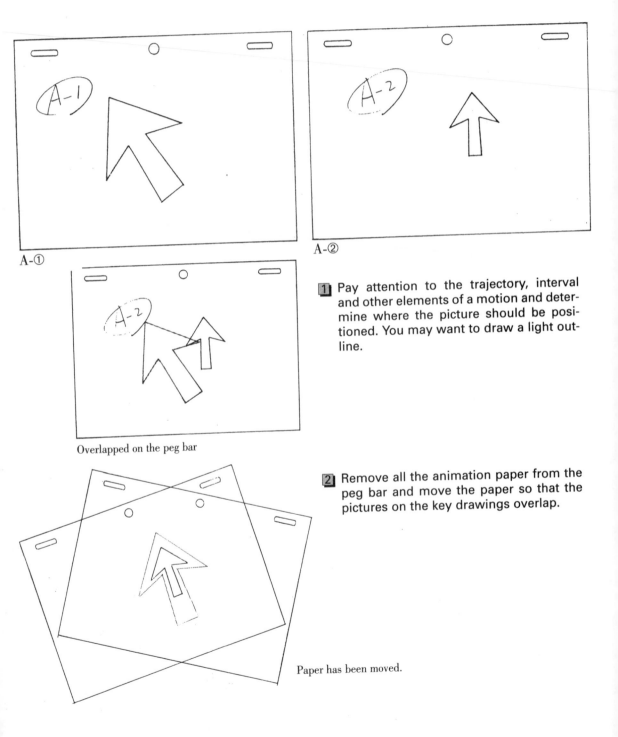

A-①

A-②

Overlapped on the peg bar

Paper has been moved.

1 Pay attention to the trajectory, interval and other elements of a motion and determine where the picture should be positioned. You may want to draw a light outline.

2 Remove all the animation paper from the peg bar and move the paper so that the pictures on the key drawings overlap.

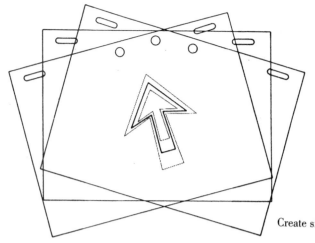

3 Place the animation paper with the outline on top so that it overlaps with the key drawing. Look at the edge of the animation paper and the orientation of the peg bar holes to make sure that each forms a uniform arc.

4 The two key drawings and the outline overlap. In this position, draw a picture intermediate to the key drawings. If the picture is not intricate, all you have to do is simply draw lines between the two lines.

Create size and shape of interval

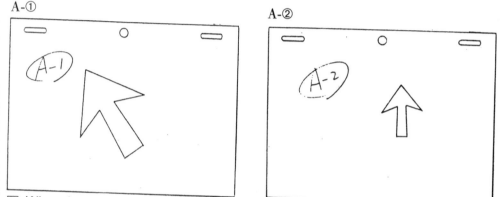

A-① A-②

5 When there is a big difference between the two key drawings, perform peg bar alignment multiple times at different parts to come up with one picture.

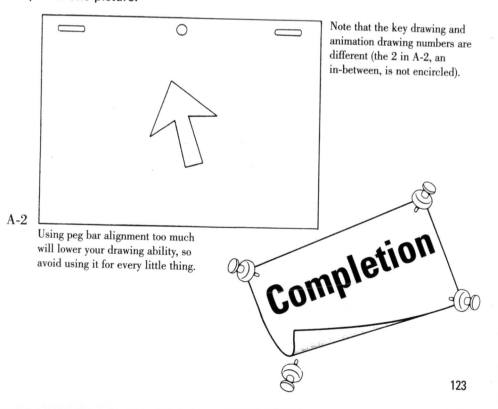

Note that the key drawing and animation drawing numbers are different (the 2 in A-2, an in-between, is not encircled).

A-2

Using peg bar alignment too much will lower your drawing ability, so avoid using it for every little thing.

Completion

Filling in a time sheet

Fill in the key drawings with consecutive numbers. Divide overlapping cels into A, B and C, etc. The black dot indicates where an in-between will be inserted.

For writing actors' lines. Make them as long as you think it will take to say them.

Place to write title and story number.

For indicating camera work.

Each horizontal row of boxes is equivalent to one frame of film. Looking from left to right, you can see the cel numbers and camera work at a glance during filming.

All of this is only one second of animation. This time sheet can hold a total of six seconds of animation. A long cut can consist of two or three time sheets.

Write cel numbers as indicated on the key drawings. Cel numbers will be the same as the key drawing numbers except in special situations. A circle is

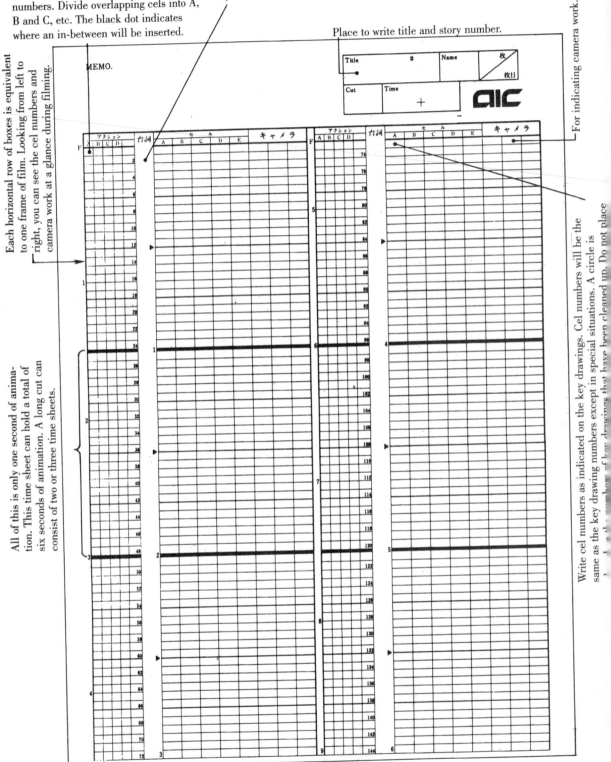

Character Design

Do you all have your own original character? It does not matter if it looks similar to that of a famous artist. Drawing will be more enjoyable if you have a character that is easy for you to draw. The question is can your character be used in any kind of animation?

There are two main types of characters that are used in animations

Realistic characters Cartoon-like characters (deformed)

There are also a variety of stories.

Warm family animations Mecha and robot action stories

School love stories Sports stories

Fantasy stories, etc.

Each type of story has its own concept of the world and characters that match that concept. You may have to abandon the characters you can draw easily and make characters demanded by the concept of the world.

A cute, cartoon-like character (deformed)

A slightly cartoon-like character capable of comical actions

A photo-like character with realistic height

Making cartoon-like objects match characters

How cartoon-like you should make your drawings is
not limited to characters. Think of the objects in a
picture as part of a character.

If the character looks real, the sandbag should
look real as well.

A real sandbag is not inflated like this. The sandbag
was made cartoon-like to fit the image of the picture.

The size of a receiver relative to a real human is used
without alteration.

The size and shape of the receiver match the small,
cartoon-like hand.

If the character is of realistic height, the door should be long and thin.

A door next to a cartoon-like character should be just big enough for the character to fit into.

Objects drawn faithfully are very realistic. You cannot put cartoon-like characters next to such objects.

Objects are altered to match the style the characters are drawn in, but note that in the case of cars and some other objects, there is not too much difference from their realistic counterparts.

Creating Animations on a Computer

As we have demonstrated, production of cel animations requires a tremendous amount of time and labor. As such, people who are good at their respective tasks collaborate to produce them. In other words, one person does not perform all the production tasks. They are divided up among many people. There are many people who want to make an animation by themselves, but that is like saying you want to build a car, which would involve designing the car, manufacturing the metal, plastic, urethane, rubber, glass and cloth and putting it together all by yourself, so you can see that it entails an enormous amount of work.

With the spread of personal computers and their increased performance, however, people can now make animations relatively easily without any special equipment if it is for their own personal pleasure. You need the following to make animations on a computer.

1. Personal computer
2. Graphics software
3. Animation software

You can make a very simple animation with just the above.

You also need the following if you want to make a higher quality animation.

4. If you use editing software, you can adjust the timing of movements and more easily join cuts.
5. If you have a scanner, you can scan into your computer pictures drawn accurately by hand.
6. If you have a video input device, you can record your animation on video.

If you spend the right amount of money, the quality of your animations will be the same as the quality of those on television. We suggest you start by having a small character move around a little.

Use of computers is now commonplace in the animation industry. Computers are also a necessity for people in the film industry as well. If you are thinking about becoming a part of the industry in the future, it cannot hurt to familiarize yourself with the use of computers in film.

The software's airbrush
function was used for gradation.

Contour lines were drawn as animation
pictures and input using a scanner.

Background lines were cre-
ated using 3D computer
graphics called fractals.

CG: Hiroki Takeuchi

Types of computer graphics

There are two main types of computer graph-
ics: two- and three-dimensional.

Two-dimensional computer graphics

You draw a picture on your computer like you
would on paper. It is like drawing a picture directly
on your computer monitor, so it is very similar to cel
animations.

Three-dimensional computer graphics

This is like making a doll inside your computer. You
let the computer compute how the graphics will be
shown on the monitor. All you do is indicate the
shape, color, camera work, lighting and motion.

Common way of making a 2D animation

Preparation of animation drawings
• Done by hand and involves materials (pic-
tures on paper)

↓

Scanning
• Everything from this stage on is processed
by the computer

↓

Coloring
↓
Camera work Done on computer,
↓ no materials
Editing
↓
Completion

Scanning

You input the lines of animation drawings into your
computer with a scanner. You can keep the frames
aligned if you attach a peg bar to the scanner.

* Scanned lines are often broken. You touch them
 up on the computer without the color escaping.

* There are two ways to handle backgrounds. You
 can scan a colored drawing or you can scan a line
 drawing and color it on the computer.

Coloring

Use the colors of your choice. Just remember to use
the same colors for a character even if the picture is
different. Unlike cels, you do not have to get too
nervous because you can always redo it if you make
a mistake.

Camera work

You can magnify and reduce pictures to a certain
extent, but in the case of major camera work, you
will need large materials for that purpose for both
characters and backgrounds. Like cel animations,
you have to have a plan when using a computer as
well.

Editing

If you designate a motion on the software's internal
time sheet (or its equivalent), it should execute the
motion just as you designated. Note that computer
animations are sometimes 30 frames per second.
This is where you splice cuts together and adjust
the length of cuts so that the scenes flow smoothly.

Animator Aptitude Test

Question 1 Choose the word (A, B or C) that matches the state of mind and position of the character and how the character is viewed by the audience for each of the following three pictures.

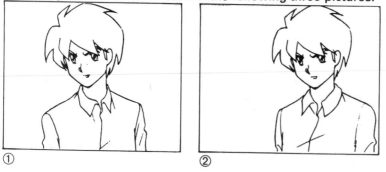

① ② ③

A. Calm / B. Confrontational / C. Cornered

Answers:
① B / ② A / ③ C
Score: 10 points for 3 correct answers,
5 points for 1 correct answer and
0 points for no correct answers

Question 2 (Same as Question 1)

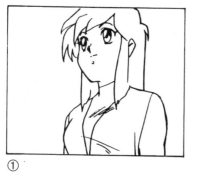 ① ② ③

A. Superior / B. Equal / C. Inferior

Answers:
① A / ② C / ③ B
Score: 10 points for 3 correct answers,
5 points for 1 correct answer and
0 points for no correct answers

Question 3 (Same as Question 1)

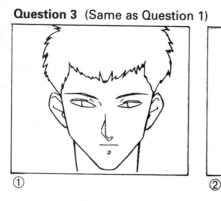 ① ② ③

A. Stranger / B. Friend / C. Oneself

Answers:
① C / ② A / ③ B
Score: 10 points for 3 correct answers,
5 points for 1 correct answer and
0 points for no correct answers